There is nothing like a good reporter to tackle a tough story, and there are few stories tougher than a racial murder…It takes a relentless, disciplined curiosity to search for the truth through a maelstrom of myth and fantasy and self-righteous bigotry, and to recognize at the end that there are many truths, no absolutes…John DeSantis…obviously knows how to talk to people, how to dig out facts and how to report his findings in human terms, with compassion.

—*New York Times*

THE THIBODAUX MASSACRE

Racial Violence and the
1887 Sugar Cane Labor Strike

JOHN DeSANTIS
FOREWORD BY BURNELL TOLBERT

THE
History
PRESS

Published by The History Press
Charleston, SC
www.historypress.net

Cover: A lone worker walks through a Louisiana cane field, possibly from the late nineteenth century. *New York Public Library*.

First published 2016

Manufactured in the United States

ISBN 978.1.46713.689.1

Library of Congress Control Number: 2016943917

This book is dedicated to the memory of those who died in Thibodaux as a result of events on November 23, 1887, both known and unknown.

It is also dedicated to my sister, Susan Bottie, and her daughters, Jacqueline and Julia, who are living proof of a bright and beautiful future for this world.

CONTENTS

FOREWORD

I was introduced to the story of the Thibodaux Massacre long ago as a young boy by my grandfather Melvin Ballard. He worked as a sugar cane laborer all his life. His wife, my grandmother Nellie Ballard, was also a sugar cane worker. For some years, she also worked inside the plantation owner's home. She cooked, cleaned and played a big part in helping to rear his children.

I was educated about all of this when I went as a young man for my first job. Once I mentioned who my grandmother and grandfather were, it was on. I left the interview with a lot more knowledge about my grandparents—and a job.

As a young boy, I stuck with my grandfather a lot. He was a fisherman, hunter and carpenter. He could do just about anything, and he would do it well. I learned a lot from him. On and off on those fishing trips, or while just plain talking, he would mention in bits and pieces what his parents told him about the massacre. All I could do was listen. I had no idea what he was talking about, if this was real or if he was joking. But the stories stayed with me, and I was always curious.

One day, I decided to look it up and found some information about it. That was when my own research started. I was so surprised to know that this horrible event had actually happened here, where I live. Over eleven years of serving as president of the Lafourche Parish NAACP, people have asked me about it, but I had very little information. The biggest question that all of this has raised for me is how many other atrocities have been committed here and in other places that are still hidden in a dark past.

Foreword

One day, my wife and I were riding north along Bayou Lafourche, a route from Thibodaux going toward Napoleonille and Labadieville, past many former plantations that still have large trees. These were the plantations where many black people from here lived and worked at one time or another.

"If these trees could talk," my wife said.

I asked what she meant.

"I wonder how many blacks have been hanged in some of those trees," she said. It was an emotional moment, and I was speechless.

The answers to those questions are difficult to find without people willing to labor to uncover the truth.

And so, I thank God for those with the courage and bravery to stand up for what they believe is good and right for the people. I also thank God for the bravery, courage, love and respect displayed by everyone who worked so hard to find the truth about this horrible, dark past and speak for those who cannot speak for themselves. That is what history is all about—telling their story. Let us learn from the past, and let us not repeat it.

Burnell Tolbert
President, Lafourche Parish Branch of the
National Association for the Advancement of Colored People
Thibodaux, Louisiana, May 2016

PREFACE

My first knowledge that a mass murder of black plantation workers occurred in Thibodaux, Louisiana, came in 1995, shortly after I began work for *The Courier*, a newspaper in nearby Houma then owned by the *New York Times*. Details were scant. Various accounts placed the number of dead as high as three hundred. As a reporter whose work included extensive coverage of more recent racially motivated crimes, in New York City and elsewhere, I certainly wanted to know more.

Records, such as they were, were consulted. There was a paucity of details that might act as guideposts. I asked questions, plumbing generational memories, and found that perceptions of the atrocity's severity were very much split along racial lines. Whites who were at all aware of the event downplayed its brutality and significance. Blacks with such knowledge tended to side with more sensational accounts. Elderly people acknowledged that something had occurred, but it became clear they had not passed any of what they knew on to their children or grandchildren.

Several scholarly works had provided accounts, often using similar primary material, and these offered something of a roadmap. My hope had been to independently determine enough in the way of verifiable fact to provide an account relevant to present-day readers. In 2011, I left *The Courier* and its sister publication, the *Thibodaux Daily Comet*, and, after a two-year hiatus, went to work for the *Tri-Parish Times*, later to become the *Times of Houma*, a newspaper owned by Rushing Media, a private local company.

The 2015 murders of nine innocent people at "Mother" Emmanuel AME Church in Charleston, South Carolina, and the resulting national dialogue resounded even in extreme south Louisiana. A decision by the New Orleans City Council to order statues of Confederate heroes removed as public nuisances intensified debate, and with my editor, Shell Armstrong, a decision was made to present, as contextually as possible, the story of Thibodaux's bloody secret on the newspaper's pages. The article was written and drew attention. I was then contacted by Amanda Irle of The History Press, who asked if I was interested in writing a book on the subject.

I jumped at the chance but was seized by fear of inadequacy. What could I do, I wondered, other than present what had already been reported except in longer form? What new facts could be plumbed other than what I had already discovered over those twenty years of curiosity and frustration?

When the commitment was made, a key appeared to turn in some metaphysical lock. From the archives of Nicholls State University appeared a long-lost list of eight victims, likely far fewer than the actual death toll but enough to allow further investigation. Reviews of census lists and interviews revealed more information, which led to further research. A trail of historical crumbs led to the pension files of Jack Conrad, a former slave and veteran of the U.S. Colored Troops, who was shot and wounded in the massacre.

The Conrad files presented, for the first time, direct accounts of what occurred in Thibodaux, including confirmation of deaths of unarmed people, from the mouths of black people submitted under oath. This was not because the incident itself had been investigated—it never had—but because of an ancillary inquiry into the related matter of Jack Conrad's injuries. In 1890, Congress passed a law that allowed Civil War veterans to file for pensions if they could not work, even if their injuries were not related to the war so long as they came about through no fault of the veteran. Coupled with the newspaper accounts, private correspondences of the day and other materials, the Conrad files confirmed the killing and wounding of innocent people on the basis of race in an atmosphere poisoned by concepts of white superiority and panic fed by rumors, as well as a resulting breakdown of law and humanity. There could be no doubt, after all available facts were taken into consideration, that somewhere in Thibodaux exists an as yet unprocessed crime scene.

Because of the light Jack Conrad's files shed on this event, his personal story is interwoven throughout this narrative. He is the living, breathing and talking representative of all those whose voices have, until now, been silenced

by the shoveling of dirt on unmarked graves or the unseen decay of earthly remains in swamps and woods.

A number of people asked me while I worked on this project why I would wish to bring up such an event now that it had been laid to rest and relegated to the past.

My reply was and is that reparation for a society's past sins does not always come in the form of financial compensation but, in a very spiritual sense, by the mere telling of truth, the acknowledgement and baring of uncomfortable fact.

Perhaps now, nearly 130 years after this tragedy occurred, the dead can finally rest, and the living can take comfort that through the telling of truth, some measure of justice has been done.

ACKNOWLEDGEMENTS

I am indebted to many individuals, organizations and institutions who contributed in varying ways to my ability to tell this story in as much detail as appears here. Primary among them is Clifton Theriot, who, as head of Special Collections at the Nicholls State University Ellender Memorial Library, located with some difficulty the coroner's report and other documents related to this tragedy that had for some time eluded discovery.

Tara Z. Laver and Germain Bienvenu of the Louisiana State University Library gave patient and thorough assistance.

Judy Riffel, who retrieved the Mary Pugh and Gay-Plater letters from LSU, deserves special recognition. Phillip R. Cunningham of the Amistad Research Center at Tulane University was likewise helpful in tracking down needed information and allowing me prompt access.

Dawn Chitty, of the African American Civil War Memorial Museum in Washington, D.C., performed an invaluable service by locating the pension files of Jack Conrad and related documents at the National Archives. Laura Ann Browning of Montegut, Louisiana, took time away from her own research project to provide counsel and background material. Marie Till of the University of Illinois at Urbana-Champaign, History, Philosophy and Newspaper Library; Mrs. Gerrie Besse of the Morgan City Archives; and Lafourche Parish clerk of court Vernon Rodrigue and his employees all went above and beyond their routine duties.

Thanks are also due to Raymond Legendre, a valued colleague who boosted my morale at a critical time in my research and writing, as well as

to Kevin Portier, who used his love of history to help me interpret copies of aged documents. Robert Walker of Houma and Richard Williams of Corinne, Utah, both dear friends, provided great moral support, as did Joe Carella, a former schoolmate whose friendship I also cherish. Lucretia McBride's knowledge of slave cemeteries and other cultural information played a role in helping me better understand some esoteric but important concepts during my research. Thanks are also due to Louis Aguirre of the Diocese of Houma-Thibodaux and its archivist, Kevin Allemand, as well as Patty Whitney of the Bayou History Center. Pamela Harris Coward supplied essential information on the Rhodes family of New Orleans. Bea and Nelson "Smokey" Dantin of Houma provided a secure and pleasant place to reside, within whose walls this book was conceived and written.

Of particularly notable assistance were Rhett Breerwood and Beverly Boyko of the Louisiana National Guard Museum at Jackson Barracks in New Orleans, who shared their time and knowledge in crucial early stages of research.

Bill Ellzey of *The Courier* in Houma, Louisiana, provided encouragement and information.

Shell Armstrong, my editor at *The Times* of Houma, allowed me the freedom to research this event for an initial story I wrote that appeared on its pages.

Burnell Tolbert, president of the Lafourche Parish Branch of the National Association for the Advancement of Colored People in Thibodaux, provided needed guidance and information. Jerome Boykin, president of the Terrebonne NAACP, also shared information and proved quite helpful, as did former Terrebonne councilman Alvin Tillman and current council members Arlanda Williams and John Navy. City council member Constance Johnson also provided encouragement and help. Richard Adams, worshipful master of the St. Joseph Lodge No. 15 F&AM in Thibodaux, and Charles Mosley of Thibodaux also provided assistance.

Attorney Robert Pugh, a descendant of the Pugh family of Madewood, did his best to supply needed background information, as did David Plater and John Robichaux of Thibodaux. Lee Shaffer of Ardoyne Plantation generously allowed me use of his family's microfilmed historic papers and provided needed clarifications. Margie Bailey Scoby of Houma and the world and Charles Mosley of Thibodaux gave assistance and connections.

Early in my research, Dr. Jeffrey Gould was kind enough to share his *Southern Exposure* article on the massacre; Stephen Kliebert, whose

abbreviated history of the massacre is ubiquitous on the World Wide Web, shared his thoughts and provided my initial view of the reports filed by General William Pierce.

My partner, James Loiselle, contributed his photographic talents, patience and support during this project.

There were also people, some of whose names I will never know, mostly residents of Thibodaux, who answered random questions and suffered my genealogical quizzing. Amanda Irle, acquisitions editor at The History Press, displayed great patience and provided solid guidance throughout the initial drafting process and never flagged in her belief.

PROLOGUE

Thibodaux, Louisiana
November 23, 1887, 7:00 a.m.

Bleeding from his chest and right arm, Jack Conrad squeezed himself under the simple wood-framed house on St. Michael Street as members of the mob, maybe fifty strong, kept on firing, clouding the air with acrid smoke. "I am innocent!" the fifty-three-year-old veteran called out, protesting that he had nothing to do with the strike of sugar laborers, nominally the cause of the violence. He pressed his chest against the cold ground and felt hot blood pooling beneath him. Another ball ripped through Conrad's flesh, and he pushed his face against the earth and weeds.

Nearly a quarter century had passed since Jack and other members of the Seventy-fifth U.S. Colored Troops stormed Port Hudson, doing a job the white senior officers did not believe possible, wresting the high ground from the Rebels and opening up the Mississippi River for Yankee gunboats. They fought for their own freedom, hoping a better life would result. But the war's outcome made little difference on the sugar plantations. Now, here he was, cornered like a cur beneath his own home, playing dead while bullets whizzed and hot, spent cartridges plinked onto the dusty street, the scuffed boots of the regulators and the hooves of their cantering, spooked horses a breath away.

"He is dead now!" one of the men called out. "Let us go."

The voices trailed off as the mob moved on to a house on Narrow Street. More shots rang out amidst wails of women, shouts of men and the unceasing cries of babies. The chronic cough, the one that made Conrad's war buddies joke that he would

die of consumption, had to let loose, scraping exposed shards of shattered collarbone deeper into raw, bleeding flesh.

A pair of arms—Jack wasn't sure whose—pulled him out from under the house and carried him inside.[1]

———•———

Jack Conrad was one of many people shot in Thibodaux, Louisiana, on November 23, 1887, although he, unlike many other victims, lived to speak of what is now called the Thibodaux Massacre.

White regulators, angered by a month-long strike of mostly black sugar cane workers in two Louisiana parishes, evicted from plantations and taking shelter in Thibodaux, spread terror and death. Some of the perpetrators and their supporters—identified in this book—were from some of the most upstanding families in town. Some of their descendants to this day hold positions of power and esteem. Records disappeared. Nobody was ever held accountable.

Multiple accounts of the day say the shooting went on for nearly three hours throughout the neighborhood east of Morgan's railroad tracks, called to this day "back-of-town," then—as now—home to many African American families.

A diluted account of what occurred is contained in a journal kept by the priest of Thibodaux's Catholic church, the French-speaking Very Reverend Charles Menard. Each year since 1849, when he first arrived in Thibodaux, Père Menard penned a summary of the year, baptisms of children, the burials of the Catholic dead and other events of note.

His journal for 1887 relates that a large tomb was built at the center of the church cemetery for the priests who might wish burial there. It describes in detail the tomb-blessing ceremony, marked by a procession with six banners and ranking church officials. It then makes reference to the strike and the violence, the victims of which most likely were left in little more than shallow graves, with no tombs or markers to note that they had once labored and lived:

> *There was a strike, directed by the famous Knights of Labor, from the North. It concerned raising the wages of those who work during the sugar cane grinding season. The negroes, the large majority being simple and very ignorant allowed themselves to be led by bad advisors.*

Some of them went out on strike and wanted to prevent the others from working. There was much concern among the planters who foresaw the possibility of their abundant crop being lost by what could be a very disastrous delay in grinding. They were obliged to find new workers and to take precautions for their protection against violence from the strikers. Several shots were fired at the non-striking workers during the night and several were slightly wounded. Militia companies were organized. A militia company with a machine gun came from New Orleans. Thibodaux was flooded with striking negroes, who began to make threats to burn down the place. It became necessary to place guards throughout the town. Everyone armed himself as best he could. On Nov. 23, about 5 o'clock in the morning, a picket of six men stationed on the edge of town was fired upon. Two of them were seriously wounded... This fusillade angered the other guards who rushed to the scene and began firing on the group of negroes from whence the shots had come. It was every man for himself. A dozen were killed and there were some wounded. The day passed with marches and countermarches to force the unemployed negroes and those without a domicile to evacuate the town. All left promptly to go to the country. The negroes realizing that they had been tricked and duped went to the plantations and asked for work without conditions. Thus was concluded the famous strike which was bad for both the planters and the workers. Grinding proceeded in calm and peace to the satisfaction of all.[2]

The mainstream press, just like Père Menard's journal, did little to relate the true horror of the attack now known as the Thibodaux Massacre, instead perpetuating a belief that it was a regrettable but excusable—even justifiable—indiscretion. His estimate of a dozen killed, like the official acknowledgement of eight dead, is in all probability another understatement. New, credible accounts of the massacre include estimates that the shooting went on for somewhere between two and three hours. Estimates of eight to a dozen dead, given that information—which is consistent with other accounts from totally different sources—are inadequate. Suggestion by historians of thirty or more killed, including estimates as high as sixty, are likely more accurate.

Details that include identities of some dead, and eyewitness accounts never before publicly seen, lead to three conclusions. One is that, on the morning of November 23, 1887, gangs of white regulators performed the tasks of judge, jury and executioner on the streets and in the homes

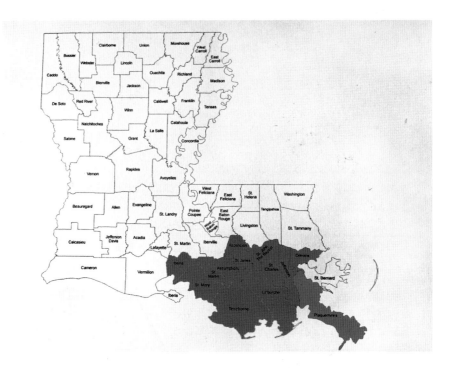

The shaded area shows the region in Louisiana where sugar cane is primarily grown, mostly south and east of New Orleans and south and a little west of Baton Rouge. *Louisiana Department of Culture, Recreation and Tourism.*

of black Thibodaux residents, killing as many as sixty people. Another is that no official inquiry into the identities of the killers was ever made. The third is that the dead can and do speak, if we do our best to listen.

Part I

SUGAR, SLAVES AND CIVIL WAR

1

BITTERSWEET BEGINNING

The Louisiana parishes that produce sugar span over seven thousand square miles between New Orleans and Baton Rouge and south to the Gulf of Mexico. Their rich soils developed from sediment left amid meanderings of the once untamed Mississippi River. The river's fluvial offspring became the streams called *bayuk* by native people; the word was later transformed into bayou. The equivalent of creeks in other places, highly navigable and in some cases as wide as small rivers, the bayous and friendly soils beside them made a great combination for raising and then shipping cash crops, indigo at first and, later, sugar cane.

Issues of labor and race were intertwined in the land that came to be called Louisiana from the earliest appearance of white Europeans. Attitudes and expectations from that time shaped events for centuries to come. The degree of inhumanity that was displayed in Thibodaux in 1887 would not have been possible had white prerogative and objectification not survived. It began when the French explorer Jean-Baptiste Le Moyne, Sieur de Bienville, established his headquarters on the Louisiana territory's Gulf coast, at the site of present-day Mobile, Alabama, in 1701. Bienville later turned his tall ships and sights to a strategically located crescent bend in the Mississippi River that eventually became the city of New Orleans, named for France's Duke of Orleans.

The colony grew in fits and starts, two steps forward and one step back. Upriver from New Orleans, in the area that would become St. Charles Parish, German settlers escaping the harsh Arkansas region were granted

land. Other Germans swelled their ranks, and eventually portions of St. John the Baptist, St. James and St. Charles Parishes came to be known as the "German Coast," or "Côte des Allemands." Initially tasked with producing food for the growing colony in return for their land grants, the Germans adopted French language and ways. In time, the broad expanses of moist, farmable lands were used not just for sustenance but also for the growth of cash crops shipped in global trade.[3]

Indigo was valuable for the dye that could be made from it, and on it the early French planters, along with the Germans, focused their efforts. There were experiments with sugar cane, which Bienville had brought with him to the Louisiana territory, but initially it was found difficult to raise. Common to all of the cash crops, along with other tasks, was the need for labor to actually tend and produce it. For this, an inexpensive labor force was required, and that meant slaves.

The first slaves in Louisiana were native people, although the arrangement did not work well for their captors. Members of the Chitimacha and other tribes escaped the plantations to which they were brought, fleeing into thick woods and swamps and eventually returning to their villages. Bienville begged France for permission to send slaving parties to West Africa for a more dependable labor source for whom home was an ocean away. After continued refusals, he instead shipped his Indian slaves to colonizers in the Caribbean "in order to get negroes in exchange." Thus began a flood of black humanity into Louisiana, first from the Caribbean and later from Mother Africa herself. Between the years 1717 and 1721, more than two thousand African slaves arrived at Bienville's outposts, many succumbing to scurvy, dysentery and other illnesses.[4]

The Chitimacha and the Africans, despite language barriers, developed a solidarity between them, and the native people assisted African slaves in escapes, often hiding them in their villages. This connection is the reason African Americans, to the present day, dress in intricate native costumes as "Mardi Gras Indians," a tribute to the native people who aided their ancestors in the past.

Plantations multiplied in what became the parishes of Orleans, St. John, St. James, Ascension, Assumption and Lafourche. Trading posts popped up on the bayous Lafourche and Teche as rule over Louisiana switched from France to Spain, then back to France, which in 1803 sold the territory to the United States. Riverboats flying American flags began to ply the Mississippi, carrying granulated sugar south to the Gulf for European export and upriver to the northern states. Grand plantations built by slaves

rose above the Mississippi's banks and along the various bayous. Among them was Bayou Lafourche, a 110-mile tributary running from Donaldsonville south to the Gulf.

A center of commerce on the Lafourche—a trading post from the time when only native people lived on the banks—was named Thibodeauxville, for founding planter Henry Schuyler Thibodaux. In 1805, H.S. Thibodaux donated a four-square-block area on the bayou's west bank to public purposes,

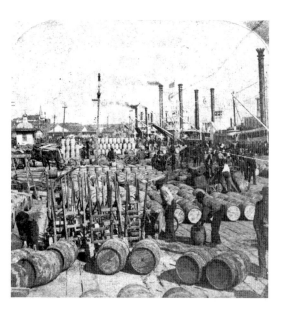

Sugar from Louisiana plantations left on ships for both domestic and international ports. *Library of Congress.*

raising there a courthouse, a Catholic church and a jail.[5] The town's early, crude wooden structures resembled more a western frontier settlement than a commercial hub destined to become the seat of Lafourche Interior Parish. When it bore that name, Lafourche included lands to the west that later broke off to become the parish of Terrebonne, its name meaning "good earth." The town of Thibodeauxville's name was changed, first to Thibodauxville and then, finally, to Thibodaux.[6]

During almost a century's development of sugar as a major trade crop, the little town grew in step. The region's original settlers, mostly of Cajun stock, were joined by newcomers cashing in on the sugar boom in all directions. In Assumption Parish, north of Thibodaux, a twenty-two-year-old North Carolinian named Thomas Pugh struck out to make his fortune in sugar. He laid the foundation for a family whose stately manors included those named Woodlawn and Madewood.

The Beattie family of Kentucky, whose members emigrated from Scotland, were among the clans that migrated to Lafourche. Such English speakers were accepted by Cajun planters like the Guillots, LaLandes and Forets. Timber was cut on site for the mansions; bricks were made by slaves. Craftsmen from Italy were brought in to create elaborate arches and friezes. Some of the more successful Lafourche Interior planters developed holdings in both

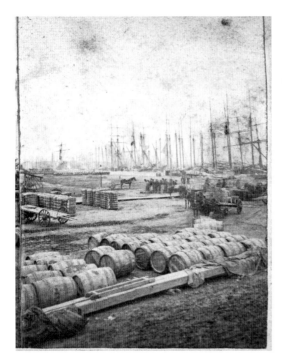

Barrels of molasses await loading at the Port of New Orleans, the busiest sugar port in the United States. *New York Public Library.*

the lands near Thibodaux and in the Terrebonne region. Among them were Jim Bowie, later to be the hero of the Alamo, and his brother Rezin Bowie. When the United States banned importation of slaves in 1820, the Bowies and the pirate Jean Lafitte conspired to smuggle them through the nation's borders, using the money they acquired to finance land purchases. These included high ground originally granted to the brothers Jose Llano and Miguel Saturino by Spain. It later became the city of Houma, named for the region's native people. The Bowies also founded an 1,800-acre plantation called Acadia just south of Thibodaux. One of their major contributions was development of a steam engine for cane production, which revolutionized the industry. After selling most of their Louisiana lands in 1826 and 1827, the Bowies moved on to adventures in Arkansas and then Texas, where Jim Bowie was killed in the Alamo stand against Santa Anna.[7]

The six-thousand-acre Terrebonne tract owned by the Bowies, sold to a man named William Wilson, was then sold to William Minor of Natchez, the scion of a successful cotton-planting family. Continuing to live in Natchez, Minor left the running of his new cane plantation in Houma to overseers, with whom he regularly corresponded. The investment appeared sound; Louisiana's annual sugar production skyrocketed from 30,000 hogsheads in 1822 to 110,000 in 1834, three years after Minor began raising it in Houma.[8]

By 1840, the perspective of planters was that the state of affairs—weather and other potential problems aside—had nowhere to go but up. That the economy was balanced and grown on the backs of Africa's sons and daughters, and their children, was not considered a matter of consequence,

An auction block at the New Orleans slave market at the old St. Louis Hotel. *Library of Congress.*

morally or in any other respect. Their status, as one modern historian gingerly described it, was accepted in mid-nineteenth-century Louisiana as the same afforded to livestock.[9]

For many decades, guided tours of Louisiana's sugar plantations provided a stilted, ethnocentric view of life in the Old South, not dissimilar to how it might have been told by the long-gone masters and mistresses themselves. In

more recent times, these plantations have become more inclusive, making an extra effort to relate details of the lives of the slaves. In St. John the Baptist Parish, the Whitney Plantation includes monuments to slaves who once worked on the property, including a "Garden of Angels" containing the names of enslaved children who died on local plantations. Lack of attention to the lives of slaves at most plantation tourist attractions, however, masked the true nature of exploitation and violence that lurked behind the sugar country's graceful live oaks and columned façades.

Brutality and conflict are aspects of Louisiana plantation history dating back to the earliest period of sugar cultivation. In the early 1800s, as black slaves boiled and spun sugar into gold for white planters, their treatment was governed by the Code Noir, or Black Code, enacted during French dominion. The code emphasized humane treatment, but "humane" was a relative word, and slaves nonetheless suffered cruelty. Planters were well aware of insurrections that had occurred in the Caribbean and greatly feared similar uprisings. Reaction to revolts was swift and deadly.

Louisiana was under U.S. governance in 1811, when slaves in St. John the Baptist Parish walked off the fields of plantation owner Manuel Andry, with farming tools fashioned into weapons on their shoulders. Leading the

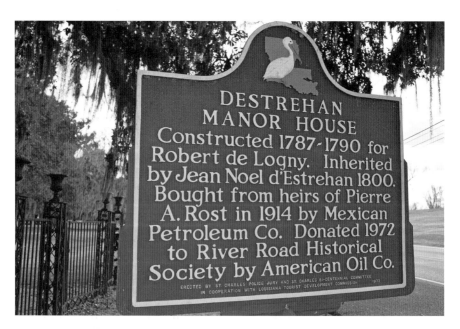

A historic marker at Destrehan Plantation, now a favorite stopover for tourists exploring Louisiana's antebellum history. *James Loiselle.*

"On to Orleans: The Negro Insurrection," a sketch by Maurice Thompson of the 1811 Louisiana German Coast revolt. *New York Public Library.*

group was a slave of mixed parentage, Charles Deslondes, behind whom they boldly marched to freedom along the winding Mississippi. Slaves from St. Charles and St. James Parishes fell in behind.

"[The slaves] divided into companies each under an officer, with beat of drums and flags displayed marching toward Trepagnier Plantation. After killing Trepagnier, from this rendezvous point the insurgents moved southeast on the River Road toward New Orleans, attacking other plantations along the way, burning several and adding arms and additional recruits." By the following afternoon, they had arrived at the Jacques Fortier plantation, where they "commenced killing poultry, cooking, eating, drinking and rioting…People began coming into New Orleans as word arrived in New Orleans about the slave rebellion. Carriage after carriage, loaded with white families and a few personal belongings, began pouring into town within hours of the initial rising."[10]

Federal troops converged on the rebels from two directions in a pincer movement on Destrehan Plantation, where tourists still walk the historic grounds. At about 10:00 p.m., the leaders, Deslondes included, were

captured. The dead rebel slaves numbered sixty, and at least seventeen were captured alive. Some prisoners were taken to New Orleans and held in the Cabildo, the building where the Louisiana Purchase was signed. Trials were held within the space of a week at several locations, with one at Destrehan.

Upon being found guilty, the convicts were immediately

> *delivered to be shot to death, each before the habitation to which he belonged;*
> *that the death penalty will be applied to them without torture but the heads*
> *of the executed will be cut and planted on poles at the place where each*
> *convict will have undergone the right punishment due to his crimes, in order*
> *to frighten by a terrifying example all malefactors who would attempt any*
> *such rebellion in the future.*[11]

Attempted revolts aside, the myth of compliant slaves overseen by kindly masters represents one extreme view of the history. The cruel, amoral Simon Legree presented by Harriet Beecher Stowe in *Uncle Tom's Cabin* represents the spectrum's opposite side. Transcripts of slave narratives recorded prior to World War II and other evidence indicate the truth as lying somewhere in between; cruelty was not ubiquitous but certainly existed. The slave narratives were transcribed as part of President Franklin D. Roosevelt's Works Progress Administration program by primarily white writers who sought out and interviewed former slaves. The writers possessed cultural biases that often resulted in Huckleberry Finn–style approximations of black dialects. The records, therefore, may appear culturally insensitive and dated to modern eyes, but excerpts are presented here as written to eliminate further distortions.

"Dey have niggers in de fields in different squads, a hoe squad and a plow squad, and de overseer was pretty rapid," John Moore, a former slave on the sugar plantation of Duncan Gregg in Louisiana's Vermillionville was quoted as saying. His interview was given in Texas when he was eighty-four years of age. "Iffen dey don' do de work dey buck dem down and whip dem. Dey tie dey hands and feet togedder and make 'em put de hands 'tween de knees, and put a long stick 'tween de hands so dey can't pull 'em out, and den dey whip dem in good fashion."[12]

Some form of corporal punishment was the rule rather than the exception, even on some of the most humanely managed plantations

Proximity of specific slaves to the "big house" and the frequency of interaction with the manor masters appears to have made a difference in how some were treated.

The slave auction block was on St. Louis Street, near Royal Street, in New Orleans. *Library of Congress.*

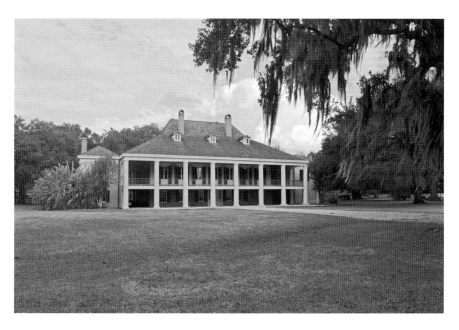

Destrehan Plantation in St. Charles Parish, where rebelling slaves were confronted by military forces in 1811. *James Loiselle.*

Southdown Cemetery in Houma is the final resting place for slaves who worked on the plantation, as well as wage workers who came later. A traditional black cemetery, it is still in use. *James Loiselle.*

The late Etta Welch, who was ninety-one years old when I interviewed her in 2001 for a news story on Southdown Plantation's slave cemetery in Houma, was born on that plantation well after slavery ended, but her father, Duncan Franklin, had lived as a slave there from the time he was a boy. Duncan's parents, William and Fannie Franklin, were house servants. Welch's recollections of what was discussed regarding her forbearers' treatment gave every indication that kindness was bestowed. Whether that was the experience of the Minor family's field workers is not known. Buried in unmarked graves adjacent to a marked cemetery of paid sugar laborers, their tales are untold, except for recordings of purchases, sales and illness in the Minor family archives.[13]

But status as a house servant was no guarantee of safety from cruelty either. Henrietta Butler, a Lafourche Parish slave, served a family to whom she referred by the name Haydee—more likely Haydel—as a wet nurse. Her disturbing recollections are contained in a 1940 WPA interview done at her later residence as a free woman in Gretna, Louisiana. "My dam[n] ole missus was mean as hell," she said, relating how Emily Haydee ordered her to have sex with "one of them mens on the plantation." A baby was born and then died. Butler then graphically discussed how she was made to suckle the infant of her mistress.[14]

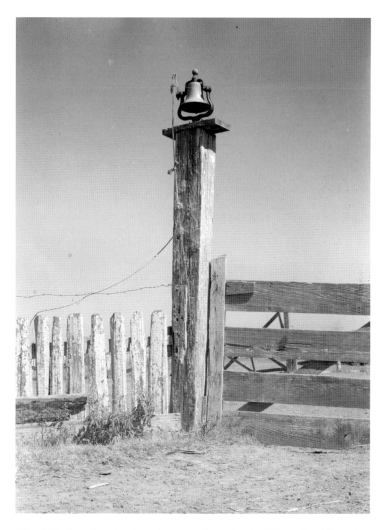

The old bell used to signal workers at a plantation in Gibson, Louisiana, in Terrebonne Parish. *Library of Congress.*

Perhaps the most damning description of slave treatment in south Louisiana was left by a Federal soldier, Homer Sprague of the Thirteenth Connecticut Volunteers, concerning escaped slaves who flocked to the Union's New Orleans headquarters after the Federal occupation.

"Some of these chattels had their backs shockingly lacerated by whipping; others had huge freshly-burned marks of the branding iron," Sprague wrote. "Many had chains on their wrists, ankles and necks. A few wore great iron collars with long projecting prongs, like the spokes of a wheel."

Sprague wrote that he himself would "work till past midnight filing off these collars."

Another Thirteenth Regiment soldier, Captain James I. McCord, confided to Sprague, "I used to think the stories about cruel treatment of slaves were exaggerated but the reality is fully equal to the worst description."[15]

In 1859, the slaves of Terrebonne, Lafourche and Assumption Parishes numbered 21,276 overall. The non-slave population of the three parishes comprised 19,923 whites, 315 free blacks and 103 native people in a year when Louisiana produced more than 350,000 hogsheads. A hogshead is a standard barrel of sugar. While it did not set a record, 1859 was one of the highest years in sugar production up to that time.[16] The work done to produce it was intense, beginning with furrows dug a yard wide and seeds planted by hand six inches deep. Workers hunched and dug, planted and tended, one row after another. Children, as well as adults, laid seven thousand plantings or more for one prospective acre of growth, depending on the variety of cane. As the crop grew, slaves swung large, heavy cane knives against the stalks to whack away weeds. When harvest time came, strong backs and arms wielded the knives against the tough stalks again. Once felled, they were loaded onto mule-drawn carts. As the carts wobbled to the mills, women and children working as "scrappers" fell in behind, snatching up segments of cane that fell off.

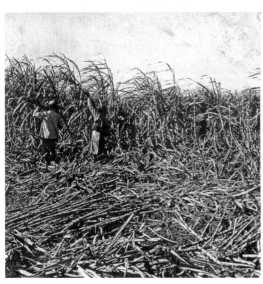

A stereograph of nineteenth-century laborers working in a Louisiana cane field. *New York Public Library.*

A greater level of skill was employed at the refineries, where the stalks were crushed under huge rollers, in most cases three times over. The juice collected from the rollers was poured into huge centrifuges that rapidly spun, plastering blocks of solid brown sugar to the walls, and the sweet juice collected at the bottom. The juice was boiled at extremely high temperatures as the crystalizing process began. More intensive work was required for breaking up the blocks of brown sugar and

other tasks. Danger lurked throughout the process. A misstep with a boiler or the handling of the searing hot juices could mean a horrible death. Slaves—and, later, paid workers—lost arms in the cane crushers. Workers from more recent times, now retired from the cane fields, said in interviews that their own work was not much different from that of the slaves or wage workers in the later nineteenth century.

Gustave Rhodes Jr., a retired Assumption Parish cane worker who began toiling in sugar when mules were still used, perhaps put it best in a 2007 interview when he said, "You worked from can't to can't, can't see in the morning till can't see at night."[17]

The degree of hard work expected on sugar plantations was well known to Jack Conrad, who tried to dodge gunfire beneath his rented house in 1887 as vigilantes fired at him unrelentingly.

"I was born and raised about four miles from Thibodaux, Lafourche Parish, Louisiana, and I was owned during slavery by Jack Kyworth, who is now dead," Jack told an interviewer. Although he spoke English—and likely French as well—Jack could neither read nor write. The name Jack Kyworth, transcribed by the interviewer, was likely an error, as no such person is recorded in Lafourche Parish or anywhere else nearby. Interviews with local historians resulted in general agreement that the reference was likely to Jacques Caillouet, the ancestor of a family whose members still reside in Thibodaux. They agree with the hunch of the historians. "Kyret," to an interviewer, is how the name Jack supplied may have sounded.

In 1834, Jacques Caillouet, who owned land about four miles outside Thibodaux, purchased a twenty-one-year-old "mulatress" named Mary with her two children, a three-year-old named Telesmao and a three-month-old boy not yet named, from Jean Baptiste Rodrigue for $1,000. Jack Conrad was born in 1834. If that is the case, then Jack spent his boyhood and many of his adult years on the Caillouet lands. Caillouet's descendants, while unable to confirm this, agreed that it was certainly a strong possibility.[18]

A light-skinned man who appears in some records as "mulatto," Jack was described by those who knew him as thin and frail, as well as intelligent and articulate.[19] There are no records indicating that Jack ever suffered mistreatment from Caillouet. Neither is there any way to know whether he was aware of the burgeoning national debate over his status and that of other slaves in later years. That debate reached a fever pitch in 1860, when a gaunt former rail splitter and lawyer named Abraham Lincoln was

elected as the nation's chief executive. Even if he could have voted—and as a slave he could not—Jack could not have voted for Lincoln, whose name did not even appear on the Louisiana ballot.

2

CIVIL WAR AND OCCUPATION

The victory of Lincoln, the president who would come to be known as the "Great Emancipator," was about to bring radical change to the life of Jack Conrad and the lives of millions of others. The era of genteel Southern knights and their ladies fair was fated to a tragic, bloody close.

Serious talk of secession swept the South with Lincoln's election but was not universally favored in Louisiana. William Minor of Houma's Southdown was among the opponents. Secession, he and other unionists argued, would threaten delicate trade arrangements with the Northern states. The passage of new tariffs, which protected sugar but not cotton, found favor with the sugar men while enraging the planters in the cotton parishes. South Carolina was first, on December 20, 1860, to secede. Mississippi, Florida, Alabama and Georgia followed. On January 26,

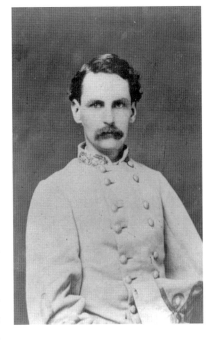

Francis T. Nicholls, who later became governor of Louisiana, was among the Lafourche region men who answered the Confederate call to arms when the Civil War broke out, rising to the rank of general. *Library of Congress.*

1861, Louisiana, during a tumultuous state convention organized to decide the matter, formally broke away from the Union.

Despite the lack of support from the sugar elite, word of secession was cause for local celebration, prompting fireworks and parades in Thibodaux. Prior to the war, there had not been, in Louisiana, a strong allegiance to the federal government. In Lafourche Parish, many residents did not even share the language their larger nation spoke, with many communicating almost exclusively in Cajun French.

Plantation owners, loyal to their state, established local militia companies and readied for war if it came. Initially declared an independent nation, Louisiana joined the new Confederate States of America on March 21, 1861.

"Around four o'clock in the afternoon all the bells in Thibodaux rang out to announce and indicate support for the ordinance," Père Menard recalled in his journals, which can still be read at the Diocese of Houma-Thibodaux's archives and at Nicholls State University.

> *They came to seek me out at the convent where I was hearing confessions to ask me if it were necessary to ring the church bells. I replied that I did not participate in politics and added that I feared the bells were sounding the death knell of the country. On the same day, voluntary militia companies were organizing. In other words, they began playing soldier.*[20]

Not all of the men "playing soldier" were initially in favor of secession.

Silas T. Grisamore, a former schoolteacher who became a merchant, was among those who did not favor Louisiana's break from the Union. But when it came, his memoir says, there was little choice but to leave behind a thriving retail business and enlist with the Eighteenth Louisiana Regiment. Grisamore, a prolific writer, chronicled the many hardships Confederate recruits suffered before ever seeing battle, while awaiting orders at a training center across Lake Pontchartrain from New Orleans called Camp Moore. The place was rife with inadequate sanitation, bloodthirsty mosquitoes and the diseases they spread, later described by Grisamore as "one mass of filth and corruption without any system of decency or propriety." Grisamore, who eventually attained the rank of major, wrote in a memoir that "sickness was prevailing throughout the camp, funeral processions were daily seen, followed by volleys of musketry over the bodies of those who had so early given up their lives, and the question 'when are we to be removed?' was seriously asked by all of us."[21]

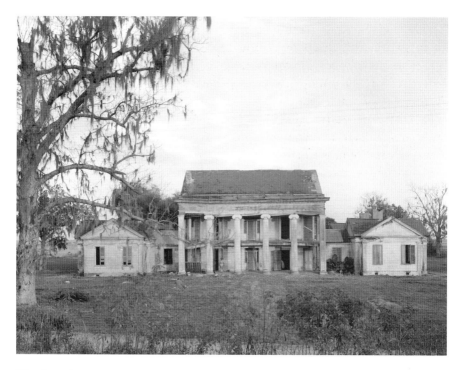

Woodlawn Plantation, demolished years after this photo was taken, was one of the Pugh family plantations. *Library of Congress.*

Grisamore would play several important roles in the events that related to the Thibodaux Massacre, as would a young fledgling attorney from the town who also went to war.

Taylor Beattie, a descendant of Scottish pioneers who fought on the colonists' side in the Revolutionary War, did not hesitate to take up arms against the nation his forebears helped found. He had attended classes in New Orleans and then at the University of Virginia, returning home to practice law for two years before mustering into the elite First Louisiana Regiment in Baton Rouge. He entered the unit one month after Lincoln's swearing in, on April 10, 1861, as a second lieutenant. Politically astute, Beattie rapidly advanced to the rank of captain, becoming a trusted advisor to generals, including Braxton Bragg—whose sugar plantation was located on Bayou Lafourche—and J.B. Hood. Beattie further honed his legal skills during the war, acting as an attorney at army courts-martial.[22]

He was, however, anything but a posturing dandy, fighting in the front lines at Shiloh, Chickamauga and Murfreesboro.

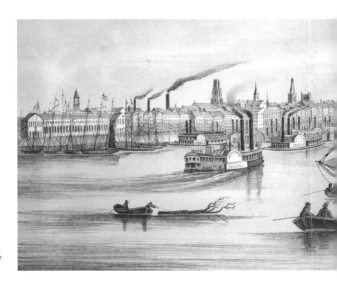

Right: New Orleans was a thriving port city when Federal troops took control of it after a skirmish in the lower Mississippi River. *Library of Congress.*

Opposite: A painting by Mark Lemon of the Battle of Georgia Landing in Assumption Parish, Louisiana, where Federal troops overran Confederate forces, allowing them to occupy Thibodaux and maintain control of the Lafourche region. *Texas author Donald Frazier granted permission for use of the image, which appears on the cover of his book on the battle,* Fire in the Cane Field.

A notable Confederate officer who would also play a role in suppressing the 1887 sugar strike was William Pierce of New Orleans.

Little is known of Pierce's life before the war, but records show that early on he joined an elite Crescent City sharpshooter team called Austin's Rifles. Pierce, whose brother was killed at Shiloh, suffered a grievous leg wound at Chickamauga, consigning him to use of a cane. Nothing in the war's annals suggests that the paths of Pierce and Beattie crossed on the battlefields, but they became well acquainted with each other in Thibodaux a quarter century later.[23]

As Beattie, Grisamore, Pierce and others did battle in places far from the sugar country, their hometowns became more directly involved in the conflict. On April 29, 1862, New Orleans was captured and occupied by Lincoln's armies. Within six months, Federal troops from New Orleans landed at Donaldsonville and began a southward march along Bayou Lafourche, with Thibodaux as their goal.

"The wind wailed fitfully or burst in angry gusts, dense rain fell, it was very cheerless, and our hearts were heavy with the tiding just received, that the Yankees had landed," states a letter from Josephine Pugh of Woodlawn Plantation, sister of General Francis T. Nicholls and wife of Colonel William W. Pugh, into whose family Taylor Beattie would later marry. "The grand army would soon be upon us, and war with all its attendant horrors."[24]

Some of the planter families fled. Mary Louise Williams Pugh, whose husband, Richard Lloyd Pugh, was serving in Louisiana's elite Washington Artillery, headed for northwest Louisiana with her children, slaves and other

relatives. They moved on to Rusk, Texas, where Richard joined them after purchasing a substitute in 1863. Soldiers in the Confederate army were allowed to pay a fee for someone else to take their place, as were draftees in the Federal forces.

At Woodlawn, Josephine Pugh learned that the Federals she feared met an opposing Confederate army at the Georgia Landing, north of her plantation, and defeated them in short order. Federal fatalities at Georgia

Woodlawn Plantation was evacuated by members of the Pugh family when Federal troops invaded the bayou country north of Lafourche Parish. *Library of Congress.*

Landing numbered 18 killed and 68 wounded, and 229 was the estimate of total Confederate losses. The remaining Confederates retreated northward as General Godfrey Weitzel and his Federals resumed their trek toward Thibodaux, burning boats docked at bayou sides along the way. Jubilant slaves poured from the quarters of the plantations the soldiers passed, bestowing them with blessings and cheers and offering to fight with them and, in some cases, to carry their bags. Following the troops, slaves abandoned Madewood, then Woodlawn. Farther down the bayou, they walked off of Leighton Plantation, former home of Leonidas Polk, an Episcopal clergyman known as the "fighting bishop," who did not survive the war, and the plantation of

Braxton Bragg, who did. Weitzel entered Thibodaux to the strains of fifes and the beating of drums, the slaves trailing behind, carrying with them not only chattel and provisions but also an entire way of life.[25]

"The negroes from far and near swarmed to us," wrote Private Harold Sprague of the Thirteenth Connecticut. "Every soldier had a negro, and every negro a mule. Many of the blacks also brought with them horses, wagons, house-furniture, provisions, bundles of clothing, bedding, with their wives and infants, till the bayou was thronged with them for miles. The question became exceedingly perplexing. What to do with them?"[26]

The Federal troops continued their occupation, to the horror of white residents. They established camp first at Ridgefield Plantation—near the current site of St. John's Episcopal Church—and later at Acadia Plantation, just south of the town, some of whose former fields are now occupied by Nicholls State University. Some of the more resistant citizens were taken prisoner by the Yankees, and Père Menard of St. Joseph's made no secret of his disdain for the Union force.

"One cannot imagine all we suffered because of the Federal camp in the neighborhood. During the winter they spent here there was continuous looting by the soldiers and disagreeable visits from them," Menard wrote, also noting the presence of the former slaves. "Moreover, the blacks abandoned their masters and followed the army, taking everything they could carry with them…[a] veritable band of looters and drunkards…uncouth and disgustingly vulgar especially when they have been drinking whiskey."[27]

The invaders sent forces southwestward to occupy Houma, where a scarcity of supplies had reduced even the most successful planters to near poverty. William J. Minor at Southdown suffered relative deprivation despite his cozy relationship with the occupying Federals.

Minor continued his operation during the war with a smaller number of slaves, as did a number of the region's other planters under Federal supervision. Lincoln's 1863 Emancipation Proclamation was limited to places in rebellion against the United States. Terrebonne, Lafourche and other Louisiana parishes in the sugar region were specifically exempted, and in some cases, soldiers enforced slave labor on the plantations of loyalists. On the other hand, they did little in Lafourche or Terrebonne to discourage slaves from leaving non-loyalist farms. Slavery did not totally end in the United States until passage of the Thirteenth Amendment in 1865.

As Lafourche and Terrebonne settled into an uneasy existence with their Federal overseers, the war raged elsewhere until defeat came to the Confederacy. In 1865, the once-proud Rebels of Lafourche and Terrebonne

returned to their plantations, in many cases with nobody to work their fields. The slaves were at that point considered free.

Professor Steve Michot, a Nicholls State University professor whose studies include the sugar region's economy after the war, said in a 2015 interview that the war's impact was "devastating."

Property loss in the three-parish region saw a steady decline from $38 per acre in 1860 to $20 per acre by 1870—a 47 percent drop. "The region would not rebound to antebellum land values until about 1920." The loss of slaves was valued at $32 million in 1870 dollars for the three-parish region of Assumption, Lafourche and Terrebonne.[28]

Officers and soldiers, in order to be granted citizenship and suffrage, were required to give loyalty oaths to the United States government, foreswearing their prior acts of rebellion, a task many described with heavy hearts.

Colonel Winchester Hall of the Twenty-Sixth Louisiana, whose officers included Terrebonne Parish sugar planters, recalled in his memoir their former farewells before returning home, performed while gathering round their flags as dirges were played.

"The colors were taken down and torn in pieces. Silently, with heavy hearts and eyes that spoke more than words, each member took a piece. I broke the staff and burned it," Hall wrote. "I stood in the road, and shook hands with each one as they filed by me, saying '*Vous avez bien fait votre devoir.*'" His words, translated to English, were "You have done your duty well."[29]

———•———

Not everyone from Louisiana who fought did so in Confederate gray. Some—including many slaves declaring themselves free—wore Union blue.

"I enlisted in November 1862," Jack Conrad told an interviewer requesting details on his Union army service. "I was a private in Company E, the Eighty-Fourth U.S. Colored Infantry…The officers of my company were Captain Miller, First Lieutenant McNair and Second Lieutenant Harry Law."[30]

Conrad's military service began in New Orleans, held by the Federals since April. At the time he enlisted, about four thousand black troops, originally organized as the Louisiana Native Guard, were performing routine support services in the Crescent City. They secured supplies, dug ditches and guarded the railroads. The risk Jack and other blacks in blue took by donning the uniform was considerable. If taken prisoner, under executive order of Confederate president Jefferson Davis, they were to be treated not as POWs but as criminals, returned to their owners if they were slaves or, in some cases, executed.

The Seventy-Fifth U.S. Colored Troops' performance at Port Hudson resulted in favorable decisions regarding the use of black soldiers throughout the Federal army during the Civil War. *Library of Congress.*

The memoirs of many evinced discontent and frustration. The men were eager to fight, but the extent of their involvement in the war effort remained unsettled for a time among the Union army leadership.

In May 1863, about six months after Jack joined up, they got their chance.

The lower Mississippi, from Donaldsonville south to the Gulf, was under Union control. But the Rebels had fortified their river position far to the north at Vicksburg, Mississippi, where General Ulysses Grant used cannons and starvation tactics to force them out. South of there, near Baton Rouge, the Confederates also occupied the bluffs of an East Feliciana Parish town called Port Hudson.

Jack and his comrades joined an army of 30,000 Federal troops massed around Port Hudson as 6,800 Confederates prepared for their assault. His regiment was presented with

The Seventy-Fifth U.S. Colored Troops played a key role in the Battle of Port Hudson, Louisiana, paving the way for victory at Vicksburg, farther up the Mississippi River. *Library of Congress.*

a battle flag and its leaders instructed that they must die if needed to keep it from enemy hands but never surrender it. Initial Federal assaults on the well-fortified Confederate position began on May 23 and did not succeed. At 10:00 a.m. on May 27, more than 1,000 black troops charged the Rebel barricades, braving canisters and cannonballs and mounting three separate assaults.

When it was determined that they could fight no more, officers counted the casualties.[31]

Despite his frailty and chronic cough, Jack Conrad escaped injury at Port Hudson. A total of 37 black troops were killed, 155 wounded and 116 captured. News of his unit members' bravery spread throughout the Northern states and New Orleans, paving the way for wider use of African American regiments, who continued to distinguish themselves in combat. After the siege at Port Hudson, Jack Conrad and the other battle-proven black troops took part in the Red River Campaign, traveling north toward Shreveport. They routed Rebel positions when they could, ultimately seeking to shut down Confederate supply lines from Texas.

He performed a number of functions in addition to infantry assignments. War records showed Jack serving as a carpenter and a cook, and he also guarded the unit's brig.

When Jack Conrad came marching home in 1865, he headed for the broad fields and relative comfort of the Caillouet plantation, where his wartime adventure had first begun and which, at that time, was the only home he had ever known.

3
UNRECONSTRUCTED REBELS

Abraham Lincoln's desire was for reconciliation between North and South, but his assassination paved the way for Radical Reconstruction supporters to make the rules. The resulting resentment of planters and their many sympathizers simmered into anger. That anger often found its outlet through violence against freed African Americans.

This Thomas Nast print depicts the 1866 New Orleans Massacre, which resulted in the deaths of white Republicans and their black supporters. *Library of Congress.*

THE THIBODAUX MASSACRE

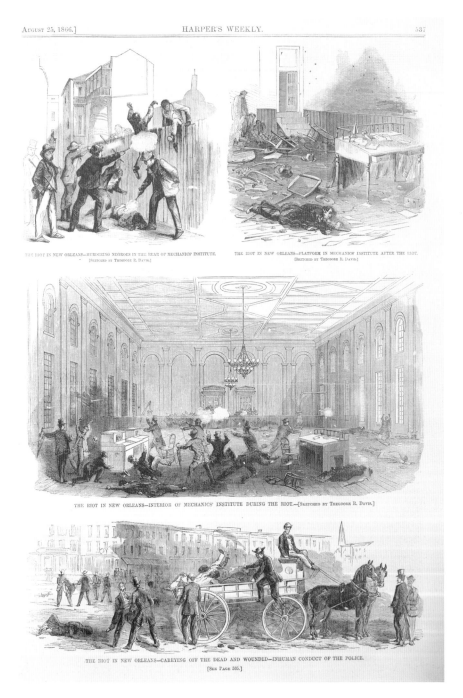

THE RIOT IN NEW ORLEANS—MURDERING NEGROES IN THE REAR OF MECHANICS' INSTITUTE.
[Sketched by Theodore R. Davis.]

THE RIOT IN NEW ORLEANS—PLATFORM IN MECHANICS' INSTITUTE AFTER THE RIOT.
[Sketched by Theodore R. Davis.]

THE RIOT IN NEW ORLEANS—INTERIOR OF MECHANICS' INSTITUTE DURING THE RIOT.—[Sketched by Theodore R. Davis.]

THE RIOT IN NEW ORLEANS—CARRYING OFF THE DEAD AND WOUNDED—INHUMAN CONDUCT OF THE POLICE.
[See Page 535.]

White Democrats killed white Republicans and their black supporters during an 1866 convention in downtown New Orleans. The violence was depicted in these *Harper's Weekly* sketches. *Library of Congress.*

The status of slaves in Louisiana was technically settled a year before the war ended, the result of a new state constitution in 1864. But the right of suffrage was not secured for them, and within a year of the war's end, an attempt to resolve the question of voting rights exploded into mob violence. Republicans, secure in their rule over the state, scheduled a convention for July 1866. A mob of enraged Democrats took to the streets during the convention, attacking African Americans and white Republicans in a bloody riot. The New Orleans Metropolitan Police was implicated in the violence. No direct action was taken against the participants, other than a declaration of martial law that lasted for three days.[32]

Harper's Weekly reported that a later congressional committee faulted Lincoln's successor, Andrew Johnson, for the riot, listing a total of forty-eight people killed, with many more missing and likely dead.

"Preparations for the massacre were made under the shield of the municipal authorities for some time before it took place," the congressional findings read.

> *Fire companies prepared and armed themselves; the police were withdrawn from their posts, supplied with revolvers, and kept waiting at their station-houses until the signal for the butchery was given, and then rushed to the bloody work with a raging mob of [former] rebel soldiers. The mayor made no effort to stop the disorder, and the military commander was misled as to the hour of the meeting, so that he could not bring up his troops in time to repress the outrages.*[33]

The federal Reconstruction Act, passed in 1867 under the administration of the former commanding general of the Union forces, put the question of black suffrage to rest, reflected in a new constitution for Louisiana approved in 1868, consistent with the state's forced approval and acceptance of the Fourteenth and Fifteenth Amendments to the federal constitution.

President Ulysses S. Grant's 1869 inauguration resulted in a second phase of Reconstruction and further turmoil in the still unsettled South. In response to Reconstruction, the Ku Klux Klan used terror to enforce the desires of white landowners. But in largely Catholic south Louisiana, the Klan did not have a strong foothold. The Knights of the White Camellia, organized along similar lines, were the primary purveyors of terror in the Bayou State at the time.

Freedom—and the right to vote—resulted in political activism among black workers eager to take part in government, particularly when issues

After Reconstruction, the terror inflicted on blacks in Louisiana resulted in some families fleeing to swamps and forests for their lives. *Library of Congress.*

crucial to their futures were at stake. A phenomenon unheard of before the war, mass participation of blacks in rural political organizations posed problems when planned meetings conflicted with work schedules. The newly organized Freedmen's Bureau, among other things, sometimes intervened when grievances by workers—and occasionally by planters—were brought to official attention.

Because of the racial dynamic in the sugar country, with so many black workers politically pitted against smaller numbers of landowners, exertion of power by the planters—sometimes with force of arms and in clear violation of the law—was viewed as appropriate and justifiable. While the law may have seen black people as equals possessing human, as well as statutory and constitutional, rights, the minds of planters who not so long before had viewed them in the same context as cattle were not as easily amended. Another Reconstruction element incited additional wrath in the upside-down nature of their postwar world: the confiscation of land from ex-Confederates who had not sworn loyalty oaths and of soldiers and officers who were killed or missing and thus never returned home.

Right: President Ulysses S. Grant. *Library of Congress.*

Below: In this Alfred Waud drawing from *Harper's Weekly*, the Freedmen's Bureau is depicted as standing between newly freed black people and unaccepting whites, indicating strong emotions on both sides. *Library of Congress.*

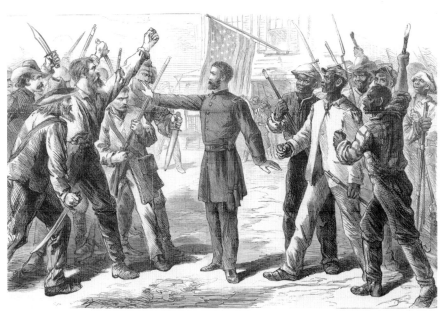

Freedmen's applications for land leases flooded Reconstruction District offices in Louisiana in attempts to have the government make good on the promise of "forty acres and a mule" for former slaves. A huge plantation in

Lafourche, once the property of T.E. Vick, a captain in the Fourth Louisiana Infantry, was among those confiscated.[34] The war was barely over when nine freedmen, on behalf of themselves and others—including women and children—applied for shares of its lands. Greenwood Plantation on Bayou Lafourche, the property of General Braxton Bragg, was also among those seized. Court records show that the seizure was due to Bragg's initial failure to take the loyalty oath. Bragg fought the seizure but was shut down in court. The seizures, with leases often leading to African Americans controlling the property, resulted in fierce resentment.[35]

Three widely publicized events—one in New Orleans and another in rural areas of the state removed from the sugar country—would signal to the world the seething tension roiling beneath Louisiana's surface. The unrest was watched closely by the Lafourche and Terrebonne planters, some of whom were related to planters in other parts of the state or dabbled in state politics.

In the west-central portion of the state, Reconstruction supporters created a new parish named after President Grant, one of eleven such Reconstruction parishes whose voting populations contained black majorities.

In 1872, Republican William Pitt Kellogg—a lawyer and former U.S. senator backed by the Grant administration—ran for governor against John McEnery, a Democrat favored by planters and ex-Confederates. When Kellogg emerged victorious, the Democrats refused to recognize him. Black voters and Republicans in general, the radical Democrats maintained, were to blame. Both felt the backlash.

On Easter Sunday 1873, white Republicans and black supporters of their ticket gathered in the Grant Parish courthouse in Colfax were taken prisoner by white supremacists armed with rifles, shotguns and a cannon. After being held for three hours, the freedmen were allowed to leave but ended up walking into an angry, armed white mob that had been in waiting. Gunfire split the Easter morning air as one by one the freedmen were slain. When the smoke cleared, between sixty and one hundred dead were counted, all but three of the bodies black. Participants in the massacre—officially called the "Colfax Riot" in the text on a plaque at the site—were said to have included members of the Knights of the White Camellia.[36]

Louisiana's political crisis continued to bubble, with attacks on Republican officeholders and threats against their supporters reported throughout the state. A new organization, the White League—heir to the rapidly disorganized Knights—acted out in the open rather than in secret, publicly stating its goal: turning out Republican officeholders and a return to white superior rule in the state. Just such a turning out was what occurred on

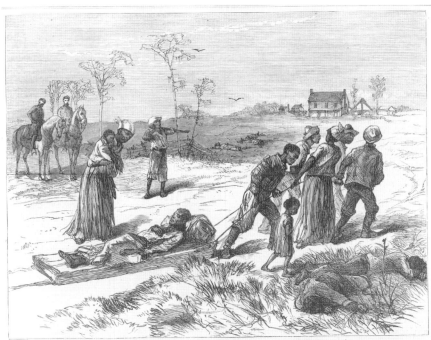

THE LOUISIANA MURDERS—GATHERING THE DEAD AND WOUNDED.—[See Page 396.]

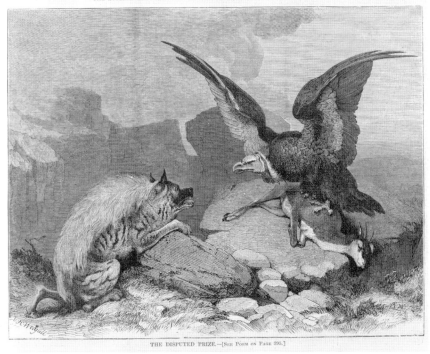

THE DISPUTED PRIZE.—[See Poem on Page 395.]

Images relating to the Colfax Riot from *Harper's Weekly*. *National Archives.*

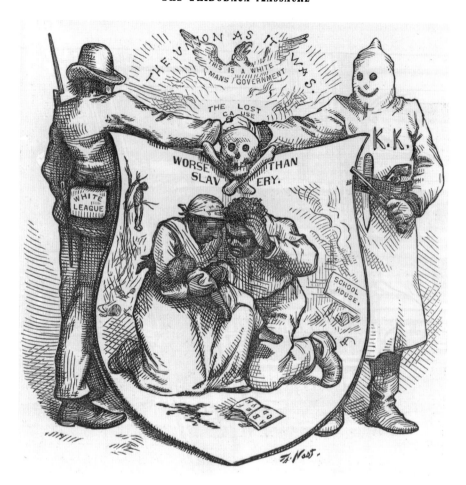

This Thomas Nast print from *Harper's Weekly* depicts the alliance between Louisiana planters and members of the White League, while a black family cowers in fear. *Library of Congress.*

August 25, 1874, in the Red River Parish town of Coushatta. Six Republican officeholders were shot and killed, as were twenty freedmen who witnessed the shootings. Other attacks on Republicans who had escaped the initial violence occurred over a period of two years.

"In rural parishes across the state, the White Leagues created a highly successful campaign of intimidation, terror, and assassination that placed a premium on the ability to assemble, strike quickly, and then disperse before either the state militia or federal troops could respond," wrote historian James Hogue in his detailed treatise on the Reconstruction years.[37]

Although there is no record of a formal White League in Lafourche, there was one formed in neighboring Terrebonne. Throughout the state, former

White Camellia members associated themselves with the White Leagues. According to Louisiana historian William Ivy Hair and other chroniclers, one member of the Knights of the White Camellia was Taylor Beattie, who returned to Thibodaux with a colonel's rank and resumed planting and the practice of law.[38] The war-hardened survivor of Shiloh and Chickamauga set his personal affairs in order, marrying in 1868 a belle of the highly successful family who built Madewood and Woodlawn, Frances Estelle "Fannie" Pugh. Recognized as an up-and-coming attorney, with a reputation polished by his judge advocate experience in the military and valuable political connections, Beattie was elevated to a high honor in the profession. In 1871, he was appointed to fill an unexpired judicial term in Louisiana's Fifteenth District, a position of great power in Lafourche Parish generally and Thibodaux in particular. A Democrat at first, the planter-officer changed affiliation when offered the judgeship, registering as a Republican and expressing a new belief in fusion politics. He became an ally of Republican governor Henry Warmoth, a former Federal army officer, who appointed him to the post. While Radical Republicans—and there were many of them—had pushed for a punishing Reconstruction, more moderate Republicans like Warmoth hoped to bridge the party gap in the nation's capital. Beattie was of a mind that only by working with the Republican power structure could the South regain its economic footing. In 1872, the electorate thought enough of the new judge to send him back to the bench for his own full term, with black residents of Lafourche Parish overwhelmingly voting his Republican ticket.

"Judge Beattie is public spirited and the willing advocate of every enterprise which promises to promote the public good and general welfare," reads a Louisiana Bar Association summary of his career, noting that

> *as an attorney he has few peers in Louisiana. He has ever been a prominent social and political and professional factor in Thibodeaux, and the many excellent qualities of himself and his estimable family are known and appreciated by the citizens thereof. He has a most beautiful and charming home and is surrounded by everything that makes one cheerful in spirit and in hope.*[39]

While Taylor Beattie settled onto the bench in Thibodaux, more trouble brewed in New Orleans. Beattie's ally, Warmoth, threw his support behind Reconstruction governor Kellogg, who ran against Democrat McEnery in the gubernatorial election. The board supervising elections was overseen by Warmoth, who declared Kellogg the victor. A black former Federal

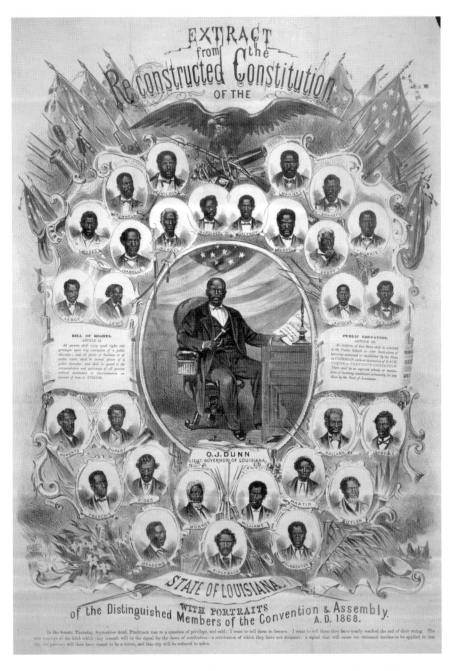

The Louisiana Constitution of 1868 granted black people the right to vote. *Library of Congress.*

officer, P.B.S. Pinchback, was already lieutenant governor. Warmoth was impeached for "stealing" the election for Kellogg. Pinchback would serve as governor for the remainder of Warmoth's term, until Kellogg could be sworn in. McEnery and his supporters claimed victory, arguing that with the election clearly stolen by the Republicans, Kellogg's assumption of the governorship was a sham. Thus, McEnery and his supporters set up their own government.[40] That they lacked the power of purse or sword meant little to the McEnery supporters. They used the Crescent City White League as their muscle, meeting regularly in the Odd Fellows Hall, a fraternal organization's building that also served as an armory for the Continental Guards.

The Guards were made up of former Confederates who had served with Austin's Sharpshooters, among them William Pierce, the New Orleans lieutenant who was wounded at Chickamauga. They were not permitted to have arms because of Reconstruction edicts, so were largely a ceremonial organization. They paraded and held social events wearing Revolutionary War–style uniforms. What they did when not in uniform was another matter, however, and evidence that some served as a civilian militia is strong. In 1873, the White Leaguers attempted a coup and stormed the Cabildo. The

The Cabildo at Jackson Square in New Orleans, where the Louisiana Purchase was signed in 1803 and where slaves who rebelled on the German Coast in St. Charles Parish were held and tried in 1811. *James Loiselle.*

revolt was a crashing failure and resulted in the arrests of some militiamen. McEnery, who denied issuing the order for the revolt, continued his attempts to govern, however ineffectively. Kellogg, still officially recognized by President Grant and Congress as the legitimate governor of Louisiana, continued to run the state.[41]

Planters in the sugar country, while watching the latest chapter in the postwar fiasco unfold, had problems to deal with closer to home. They had seen a slow economic comeback in the years that followed the war. In 1866, a mere 39,000 hogsheads of sugar were produced in Louisiana, fetching $137.50 per barrel. But by 1868, 84,256 hogsheads were produced at an average market price of $137.80. After that, prices and yields were mostly on the upswing. Then, in 1873, bad weather and other difficulties plunged yields downward, to 89,496 statewide, with a per-hogshead average price of $86.50.[42]

One of the bigger sugar operations to feel the pinch was Southdown. William Minor had adjusted to paying wages after slavery's end, a transition made easier by his prewar practice of paying small cash bonuses to slaves at harvest time and hiring freelance for harvests. He lived for only a few years past the war's end, however. By 1870, the plantation was operated by William's directed heirs, his son Henry and daughter Kate.

As the new and doleful year of 1874 approached, the Minors led other planters in a wage-cutting scheme that reduced pay from twenty to eighteen dollars per month, in some cases fifteen to thirteen dollars for each worker. On January 4, 1874, a meeting of more than two hundred black sugar workers was held at the Little Zion Church, on the outskirts of Houma, and an association was formed. Their goal was one considered radical at the time: a proposal for shares of land that they could work as farmers, splitting the profits with the plantation owners who agreed to the subdivisions. After the war, sharecropping was a solution for both planters and laborers in some portions of the South. But sugar was never considered a prime crop for such practices, in large part because of the labor intensity and land volume cane required. A more immediate goal was also addressed: a refusal to accept the proposed pay cuts.[43]

Hamp Keys, a black Republican legislator, gave a fiery speech, exhorting the crowd to refuse working for anything less than eighteen dollars per month. He urged that "if any of the other negroes did so they must be stopped, and that if any resistance was made to their just and proper claims, they would burn the houses and murder the families of the planters."

Armed white riders, according to some reports, circulated among black Terrebonne Parish communities, although no actual violence ensued. There were reports, however, of overt intimidation and threats.

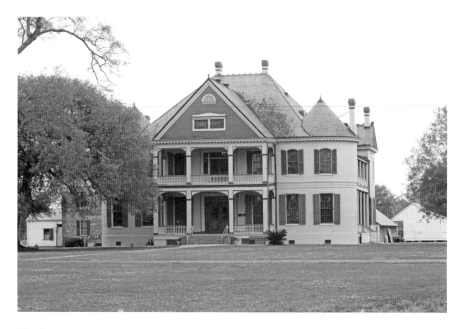

The Southdown manor house in Houma, on the grounds of what was once one of the biggest sugar operations in south Louisiana. It was home to the Minor family well into the twentieth century and is now a museum. *James Loiselle.*

Waving banners and chanting, a mob of strikers marched to Southdown and demanded that its remaining workers halt their labors, which drew a strong response from Henry Minor. He enlisted assistance from General Sims, the black Republican sheriff, who rounded up a mostly white posse of about twenty men. They converged on Southdown and stood between the plantation house and strike supporters. The strikers stood down but returned the next day, bearing arms. A camp was set up across Bayou Black from the plantation.[44]

"The sheriff not being able to do anything with his small body of men agreed to compromise with them and disband the posse if they would leave," the *Times Picayune* reported. The strikers accepted the terms and marched off, shouting and firing their guns as if they had won a great victory. They then showed up at the Houma train station, where some fired weapons into a train, wounding an unidentified young man from Thibodaux. Governor Kellogg, who up to that point was strongly favored by the black Terrebonne workers and viewed by them as a sympathizer, sought assistance from federal troops. Forty-one infantrymen and twenty-nine cavalrymen with a cannon in tow were dispatched. The throng of strikers and sympathizers swelled to

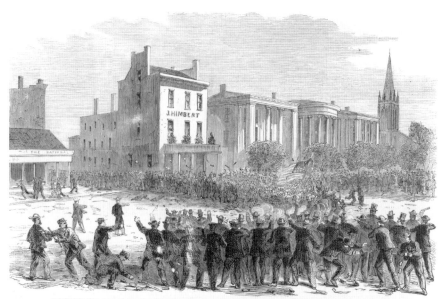

THE RIOT IN NEW ORLEANS—THE FREEDMEN'S PROCESSION MARCHING TO THE INSTITUTE—THE STRUGGLE FOR THE FLAG.
[SKETCHED BY THEODORE R. DAVIS.]

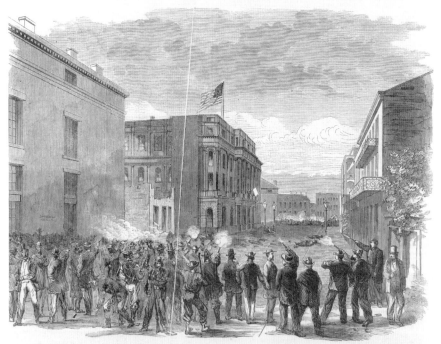

THE RIOT IN NEW ORLEANS—SIEGE AND ASSAULT OF THE CONVENTION BY THE POLICE AND CITIZENS.—SKETCHED BY THEODORE R. DAVIS.
[SEE PAGE 555.]

The Battle of Liberty Place pitted white Democrats against the state government organized under Reconstruction. *Library of Congress.*

nearly five hundred, armed with "rifles and muskets." The strikers divided their presence among three local train stops, where they awaited the troops. But a conference between a general and the firebrand legislator Keys defused the situation, which the more inflammatory publications in the state were calling a "war." The strikers agreed to cease molesting any person who desired to work, and the season proceeded with little more serious interruption.[45]

The unrest was not confined to Terrebonne but had spread to some of the plantations in Lafourche, and important lessons were learned on both sides of the dispute in both parishes. Although their job action was unsuccessful, sugar workers saw that they could indeed organize. The planters saw that the state government, despite its Republican leadership, could be effective in staring down any organization by the labor force.

Although Kellogg was responsive to the request for help from Minor and other Terrebonne Parish planters, his presence in the governor's seat did little to alleviate tensions in New Orleans, where another coup against him was planned. On September 14, 1874, a mob of five thousand Crescent City White League members confronted undermanned state forces. Commandeering streetcars that they used as barricades, the White Leaguers turned Canal Street into a battleground. As the street fighting raged, Kellogg and his advisors retreated to the U.S. Custom House on Canal Street, which White Leaguers laid under siege. The Battle of Liberty Place—what some

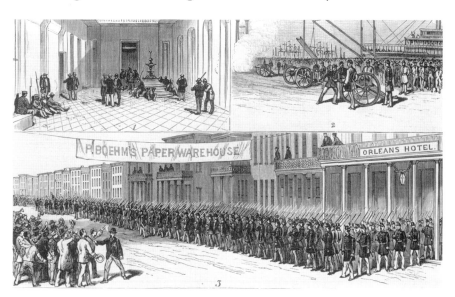

Federal troops withdraw from New Orleans at the end of Reconstruction, which was enforced as a federal policy in Louisiana longer than in any other state. *Library of Congress.*

Louisianans have called the last battle of the Civil War—ended with the arrival of troops dispatched by President Grant. All told, sixteen White League members died, and thirteen members of the state militia and Metropolitan Police were killed, as well as six bystanders. A printed memorial to the defeated White Leaguers specifically mentions William Pierce of New Orleans as one of the Democrats.[46]

Federal occupation in New Orleans continued for three years thereafter.

As New Orleans attempted political normalcy, Terrebonne Parish recovered well from its strike. But tensions were growing in Thibodaux and the surrounding Lafourche Parish countryside.

State militias had existed in various parishes before the war, and when the men who once made up their ranks came home, basic rights such as ownership of firearms were restricted officially until loyalty oaths were taken. New state militia units formed during Reconstruction, including the official militia that battled ex-Confederates at Liberty Place, contained large numbers of black members armed under state authority.

In Thibodaux, Company C of the state militia's Sixth Regiment was led by a schoolteacher named Benjamin Lewis. A black and Indian native of Maine, Lewis is believed to have come to Lafourche with an army from the North during the war. He and his companions were anything but bashful, and on Saturdays, they routinely marched and drilled on the commons of Thibodaux with weapons in hand. The sight was appalling to Thibodaux whites; an article in the weekly *Thibodaux Sentinel* quoted Henry Michelet, the Lafourche Parish treasurer, as referring to them as "black banditti" and "terrorists."[47]

Congressional testimony indicates that many "bulldozers"—those who inflicted death and injury on blacks in furtherance of terroristic or retaliatory objectives—traveled from their home parishes to those where blacks needed to be "taught a lesson." That violence was largely in northerly parishes, but the sugar country was not immune. There was talk of "regulators" in Lafourche whose actions could have been worse if not for the Lewis militia, oral history accounts indicate. Joseph Reed, a black farmer living north of Thibodaux, told his son Ulysses in later years that a "protective society" in that period aided African Americans under threat of violence. By all appearances, he was referencing the Lewis militiamen.[48]

Duplin R. Rhodes, who lived on leased land outside Thibodaux with his young wife and other family members in the Reconstruction years, was quoted by his son, Duplin W. Rhodes, as having spoken of the same organization. Both men's recollections contain references to outrages that were well known in the community, including the hanging of a black teacher.

Mary Kitchen of Chackbay looks over her family Bible as she recalls the stories told by her father, Ulysses Reed. *John DeSantis.*

How near or far from Thibodaux those atrocities occurred is difficult to ascertain. But the Rhodes account of personal events, coupled with census bureau evidence that the family indeed lived outside Thibodaux in 1870, serves as some verification.

The account by Duplin R. Rhodes of his father's story is simple but vivid. "There was a lot of political unrest going on there at the time. Unless you were working for a white person, you weren't supposed to be there," he said of the land his family occupied.

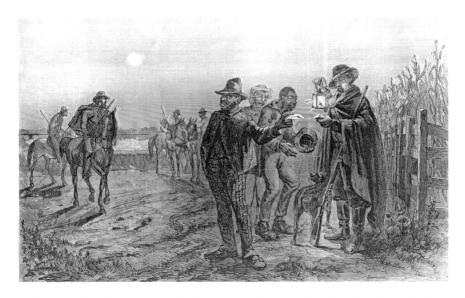

A depiction of civilian regulators, during the era of Democratic rule in Louisiana, checking the identifications of black people. *Library of Congress.*

The elder Rhodes, according to his son's account of the story, found himself on the wrong end of a group of vigilantes:

> *If you owned land, you had to get out, and the easiest thing to do is to kill you. Just hung him if you could catch him. They got rid of a schoolteacher, left the body on the street with [a] sign on it as a warning to all blacks in that location. My daddy had to make himself not to be found. He went into the woods. My mother started selling what we had. My daddy came at night and took my mother in a wagon and a horse.*

They fled in their horse-drawn wagon to New Orleans, where within a short span of years the elder Rhodes, who worked as a self-employed drayman, went into the funeral business. He founded the Rhodes Funeral Home in 1884, and it continues in business to this day.[49]

That Duplin R. Rhodes would have fled for his life in the late 1870s is an understandable scenario if the tensions caused by the elections of 1876 are any indication. Rife with fraud largely perpetrated by Republicans, the Louisiana election—along with those held in South Carolina and Florida—threw the entire U.S. presidential contest into a tailspin.

Members of the Lewis militia were among the local officials who had charge of polling places in town.

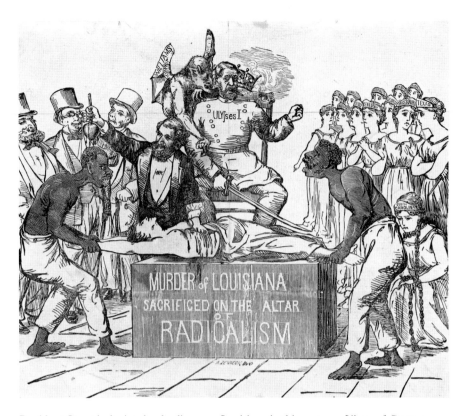

President Grant is depicted as lording over Louisiana in this cartoon. *Library of Congress.*

Among the allegations of fraud, upheld in congressional testimony, were substantiated claims that polling places were switched on the day of the election. In one case, the posted polling place, a Thibodaux warehouse that was easily accessible to the public at large, was moved to the black quarters of a plantation without the plantation owner's consent, well off the path white Democrats would travel.

Henry Michelet testified before a congressional subcommittee that there was "an enormous difference between the real voters and those that figure on the printed list."

"On the printed list the dead men were not marked off or not erased," Michelet said.

> *The convicts and fugitives from justice and the men removed from the parish were not erased. I also found a great many names there that did not exist at all in the parish. The population of the parish is seventeen*

A view of Laurel Valley Plantation in Louisiana taken from atop a water tower. *Library of Congress.*

thousand inhabitants, and a great many more whites than negroes. I find on the printed list four thousand six hundred and sixty or four thousand six hundred and seventy voters. That would make a vote and a quarter to each four inhabitants. In my summary I find seventeen hundred and seventy-nine colored men, comprising all the convicts…and I find two thousand two hundred and fifty, or something like that, of whites. These are real voters. That makes about three thousand eight hundred, while the printed list is about four thousand six hundred.

Armed mobs of blacks and whites gathered at the Thibodaux courthouse in a standoff, amid fuss about the returns. An elections commissioner refused to accept the votes that came in for one precinct, setting off friction between the two sides.

"I asked the mayor of the town to have all the stores closed where they sold whiskey," Michelet said. "The excitement calmed down. On the part of the whites, they were perfectly calm. The negroes assembled themselves

with arms, numbering in the neighborhood of two hundred men, and all the women in the vicinity with cane-knives and forks and coal-oil. They wanted to burn the houses."

Judge Taylor Beattie, who appeared to have the respect of both whites and blacks, appealed to calm on both sides, and violence was avoided. Benjamin Lewis was among the militia members accused of interfering with the election results on behalf of the Republicans, along with one of his lieutenants, by Lafourche Parish's Democratic sheriff.

The contested election ended in a deal between Louisiana and the United States, with Democrat Francis Tillou Nicholls recognized as governor

President Rutherford B. Hayes was ensured election through a compromise that returned control of Louisiana to Democrats. *Library of Congress.*

and Rutherford B. Hayes the presidential victor.[50]

Louisiana planters got an extra bonus when federal authorities agreed to remove troops from the state. Nicholls initially bided his time but eventually issued orders disarming Lewis and the other black militiamen

By 1879, Nicholls had succeeded in cementing the rule of radical Democrats, referred to as the "Bourbons," in place. He failed, however, to win nomination for a second term, deemed by the power-wielding Bourbons as too liberal because of his belief that planters should deal fairly with labor. Judge Beattie accepted the Republican nomination for governor and was bested by Lieutenant Governor Louis Wiltz, a Bourbon Democrat. After the race, Beattie returned to the bench in Lafourche Parish and continued to raise sugar at Dixie Plantation in Thibodaux and the Pugh family's Woodlawn Plantation in Napoleonville. The mostly Democratic sugar planters tolerated the Republicans among them, such as Beattie. This was because the national Republican Party was supportive of continuing high tariffs on sugar from South America and the Caribbean—one of the reasons cane planters were

not in the least bit distressed by the election of Republican James A. Garfield as president of the United States.[51]

A Union army officer during the war, Garfield was initially a strict reconstructionist. But Garfield eased his stance considerably as time went on. In his last days as an Ohio congressman, Garfield argued impressively for tariff retention. While not a champion of southern agricultural causes overall, he at least did not seek to do harm. By the time Garfield was

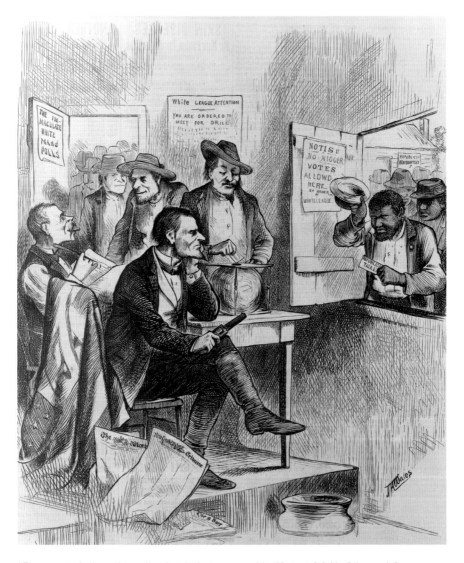

"Democrats declare victory," a sketch that appeared in *Harper's Weekly. Library of Congress.*

inaugurated, the planters saw themselves as having seats at the table in the national dialogue.

The potential of future parades by armed black men in the streets of Thibodaux or any other Louisiana sugar town was eliminated with the appointment of new state militia leaders under the command of Confederate hero P.G.T. Beauregard, the state's adjutant general. Among the guard units were those whose members acted as militia for John McEnery's shadow state government in 1874 at the Battle of Liberty Place. They included William Pierce and other members of the New Orleans Continental Guard, who, at liberty to bear arms, began entering sharpshooting matches at home and in Mississippi.[52]

In the new Louisiana, many blacks—thousands of them—found security not by fleeing to New Orleans but to places much farther away. Kansas and points west were favored by many. Mass migrations from Louisiana and other southern states drew the attention of Congress, which held hearings on the matter. It was during those hearings, in 1879, that the state of disorder in Louisiana was clearly presented to committee members as a means of explaining why the migrations were occurring.

A U.S. Senate hearing included in the record mention of an 1875 letter to President Grant from New Orleans army commander Phillip Sheridan, who wrote that "since the year 1866 nearly 3,500 persons, a great majority of whom were colored men, have been killed or wounded [in] this state."

Other testimony indicated that the bulldozing had not stopped with Reconstruction and that the count of dead and wounded blacks still mounted.

"Since the year 1868 to the present time, no official inquiry has been made and the civil authorities in all but a few cases have been unable to arrest, convict or punish the perpetrators," Sheridan's letter states. "Human life in this state is held so cheaply that when men are killed on account of political opinion the murderers are regarded rather as heroes than criminals in the parishes where they reside."[53]

By 1880, the newly elected Governor Wiltz would find himself in need of the new militias, not just in the bulldozer-rich northern parishes but also in the sugar region, where black workers were still resisting the replacement of slavery's yoke with the barely distinguishable one of wage labor.

Part II
BIRTH OF A MOVEMENT

4
TROUBLE IN TOWN AND FIELDS

While planters played politics, sugar laborers toiled, with discontent widespread throughout the region. For workers in the fields and sugar houses, freedom brought little change other than the right to vote, and even that had a bitter aftertaste. Tension was building in 1880 within St. Charles Parish on the old German Coast. The murder of a black man by a white man had no known connection to the relationship between planters and workers. But its significance—from the tragic standpoint of misdirected empowerment and likely white fear—makes it an important part of the record when looking at events leading up to the massacre in Thibodaux. If nothing else, it demonstrated that mob violence was not the exclusive purview of white Democrats but of blacks as well, as much of an anomaly as it may have been.

On the evening of September 19, 1878, the son of the St. Charles Parish attorney, one Valcour St. Martin, a white Republican and former deputy about thirty years old, was walking out of a shop in Hahnville, the parish seat. A black man named Charles Baptiste, described in press reports as "a radical," tripped over St. Martin's foot on that Saturday and was subjected to a violent push. Baptiste died a few moments later, and St. Martin was arrested and brought to the parish jail. An unusual aspect of the case was that a white man had been arrested at all for murdering a black man. Word spread rapidly among black people at stores and coffeehouses, and they gathered at the jail.

The St. Charles sheriff, George Essex, spoke with the crowd, whose members, like himself, were African American.

A mob returned later that night, armed with shotguns, muskets, revolvers and cane knives, and informed Essex that unless he turned St. Martin over to them, his life would be ended. Essex ordered his deputy to open the jail doors, and when that happened, the mob rushed in and snatched St. Martin from his cell. From there, they took him to the courthouse yard. St. Martin was riddled with bullets; his face and head were beaten to "a jelly." One newspaper reported that St. Martin had been massacred by projectiles from "no less than fifty guns."[54]

Thus, perhaps empowered by the lynching and the lack of retribution for it, blacks in St. Charles took a stand of a different kind less than a year later, with wages at the root of their protest. Plantation workers had squabbled over their seventy-five-cents-per-day rate from before the time St. Martin was lynched.

On March 16, 1880, workers again pressed demands for wages of one dollar per day but were rebuffed. They rebelled, releasing livestock from their pens. When a worker tried to interfere, he was whipped by strikers with a strip of bull hide, reports at the time said. The workers then traveled from plantation to plantation along the old German Coast, with more workers joining, much in the manner of the rolling revolt of nearly a century before.

By the time it reached Fashion Plantation in St. John the Baptist Parish, the mob numbered five hundred, many on horseback, wielding clubs, sticks and bludgeons.

Will Kelly, owner of the Ransen Plantation, told a *New Orleans Daily Democrat* reporter that he had heard trouble was coming to his place.

"A crowd of from two hundred fifty to three hundred negroes approached the gate of my residence," Kelly said.

> *My own colored employees had asked me what they were to do under the circumstances. I told them that they should continue to work until the mob ordered them to stop for it would be useless to resist them. I even advise[d] them to turn out and join them if they were required to do so. The mob having reached the front of my house became very boisterous and, shouting, said that the hands should be killed, that they were going to have their own way about the thing. Addressing those who were the appearance of leaders I asked them not to go into the yard but that if they wanted to see the hands that they should go around into the field where they work.*

Accompanied by a man named Tom Harris, Kelly observed the throng, hearing "shouts and threats of murdering."

Sugar cane growing on the lands of Laurel Valley Plantation, outside Thibodaux. *James Loiselle.*

The crowd beat Harris, Kelly and their horses with bludgeons, and they responded with pistol fire, riding away to safety.

Kelly was asked if he recognized any people among the strikers. "By sight I can only call one by name, that's Jake Bradley," he said.

Bradley, he maintained, had been arrested in connection with the lynching of Valcour St. Martin.[55]

As the strike continued, planters urgently wired Governor Wiltz for help. The strike ended without violence.

Wiltz issued a warning to the strikers, and militiamen were dispatched to the region. The troops had to physically restore order on several plantations, but no serious injuries or deaths were reported, and the laborers went back to work. Strike leaders were initially sentenced to prison but subsequently pardoned.[56]

Certainly, the planters in St. Charles saw—as had those six years before in Houma—that state government was a willing partner in the dissolution of labor actions. The state had not just kept the peace but essentially forced laborers back to work. Perhaps that growing sense of security aided the planters and their allies in their acceptance of reconnection to the nation. That acceptance was apparent through the increasing participation over the years of sugar parish communities in Independence Day celebrations, a clear display of national

The Tomb of the Army of the Tennessee at Metairie Cemetery, outside New Orleans, is the resting place for General William Pierce, General P.G.T. Beauregard and other Confederate veterans. *National Archives.*

unity. By 1881, there were many grand plans for Independence Day galas. But two days before the holiday, a pall fell on the nation and the state.

At a Washington, D.C. train station, President James Garfield was accosted by an embittered and deluded attorney, Charles J. Guiteau, who had sought a consular post and was rejected. Guiteau shot Garfield twice with a pearl-handled British Bulldog revolver, and the president collapsed. Garfield's recuperation was long and unsuccessful. He died of complications related to the more grievous wound on September 18. As part of the official national mourning plans, New Orleans held a mock state funeral for the president, an event marked by great pomp and solemnity. Attending in all their finery as the chief honorary pallbearers were the Continental Guards, led by their captain, William Pierce.[57]

The planters lost another friend one month later, when Governor Wiltz succumbed to tuberculosis. As a former member of the Army of the Tennessee, he was buried in the unit's grand tomb at Metairie Cemetery, just outside New Orleans.

Wiltz's death meant a new Louisiana governor, whose last name was a familiar one. Samuel McEnery, brother of former shadow-governor John McEnery, seamlessly made the switch from lieutenant governor to chief executive of the state.

The transition from Wiltz's administration to McEnery's was seamless for planters, who recognized the new governor as a kindred spirit likely to help should trouble return to their fields and sugar houses.

The first years of McEnery's gubernatorial tenure saw relative calm in sugar country, with few problems other than occasional talk of labor actions that never materialized.

Meanwhile, shifts in fortunes for some whites in the sugar parishes saw greater integration of labor forces, with a few whites joining blacks in the fields and in production. Hiring white workers was particularly common at the busiest times, with subsistence white fishermen or vegetable farmers working the fields and sugar houses. Wage scales were generally equal across the color line. But interviews with descendants of sugar workers from the period indicate disparity in other respects.

"They were treated differently in terms of the things they were allowed to do," said Alvin Tillman, a former Terrebonne Parish council member and the council's first black chairman, who shared his family's recollections in a 2016 interview for this book. "The black workers could be reprimanded for

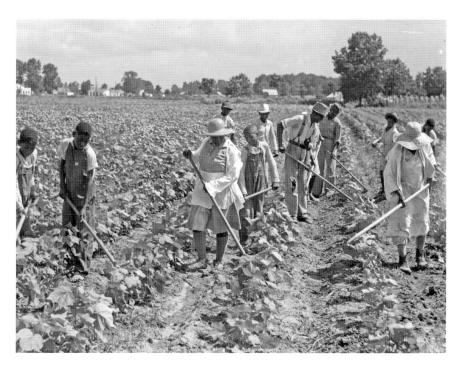

In addition to their labors in sugar fields, plantation workers also tended crops for the sustenance of the farms or for themselves. *Library of Congress.*

not doing what white workers said. The white workers were getting other commodities to take care of themselves and their families."

As Louisiana underwent great change in the 1880s, so, too, did the nation as a whole. The great northern urban centers were growing as never before. But prosperity for some meant poverty for others, and as industry grew, worker dissatisfaction grew as well. The growth of industry during the postwar period was paralleled by worker efforts to win better conditions, and they banded together with workers to achieve better conditions.

Among such groups was the Garment Cutters Association of Philadelphia, which joined in 1858 by a tailor named Uriah Smith Stephens, who at the time was thirty-seven years old. A New Jersey native, Stephens initially studied to be a Baptist minister and for a time taught school. But financial difficulties forced Stephens to find a trade, and he apprenticed as a tailor. Knowledge of the trade coupled with his interest in social justice found outlets when he joined other tailors in forming the association.

The garment cutters group folded in 1869, but Stephens was not done with his dream of labor organizing. Along with other tailors, he formed the Holy and Noble Order of the Knights of Labor, becoming the organization's first Master Workman. The Knights were not the nation's only labor movement but had an extremely high profile. Believing he could effect change through direct government, Stephens ran for Congress in 1878 on the pro-labor Greenback ticket but lost. The next year, he turned over the Knights of Labor Leadership to Terrence Powderly.

Under Stephens, the organization had operated with secret handshakes, signs and rituals, similar in some ways to Masonic orders. Powderly, an attorney and politician, wanted to open the group to public view and to cut a high public profile. The group took on an ambitious project: to organize all kinds of workers nationwide under one umbrella. By the time Powderly took over, the Knights boasted ten thousand members or more. The group's reach extended into Catholic church affairs, with Powderly asking a bishop to confer with the pope to ease bars on Catholics joining labor unions. Those negotiations were successful, with Powderly agreeing to remove "Noble and Holy" from the organization's name. Rituals developed in the past were eliminated.[58]

Establishment of an eight-hour workday and negotiations for better working conditions were priorities for the KOL under Powderly, who eschewed violence and strikes. His desire to cross racial lines in the interests of organized labor was seen as beneficial by black leaders, even if white workers were not always on board with the idea. While membership was open to all, many "assemblies," as KOL groups were called at the most local

LEADERS OF THE KNIGHTS OF LABOR.

The Knights of Labor, led by Terence V. Powderly, established local councils throughout the United States. Although Powderly played no known direct role in the sugar strike of 1887, the record shows that the Schriever local of the KOL organized the cane workers. *Library of Congress.*

levels, were segregated. That membership was open to blacks, nonetheless, was seen as progress. No less a hallowed figure than Frederick Douglass spoke out on the importance of organized labor to black workers at an 1883 convention in Louisville.

"It is a great mistake for any class of laborers to isolate itself and thus weaken the bond of brotherhood between those on whom the burden and hardships of labor fall," Douglass said.

> *The fortunate ones of the earth, who are abundant in land and money and know nothing of the anxious care and pinching poverty of the laboring classes, may be indifferent to the appeal for justice at this point, but the laboring classes cannot afford to be indifferent. What labor everywhere wants, what it ought to have and will, one day, demand and receive, is an honest day's pay for an honest day's work. As the laborer becomes more intelligent he will develop what capital already possesses, that is the power to organize and combine for its own protection. Experience demonstrates that there may be a wage slavery only a little less galling and crushing in its effects than chattel slavery, and that this slavery of wages must go down with the other.*[59]

One of the most vital industries in the nation was the movement of goods and people by rail. Pushes by management, the most powerful men in the nation, in the form of lower wages or lack of investment in safe practices or safety equipment were met with shoves from workers. An 1877 railroad strike spread from West Virginia to Baltimore and Chicago, with federal troops and state militias intervening and workers rioting in protest.

An estimated 100,000 workers had walked off at the strike's zenith. At least 100 people—mostly workers—were killed in clashes that occurred in different states and towns. The strike resulted in tougher conspiracy laws, increased numbers of state militiamen and other oppressive measures. The strike was not the result of one single labor organization's activity. Like the sugar strike in Terrebonne, as well as the ones that followed in St. Charles and St. John Parishes, the railroad strike was a component of various local incidents caused by like grievances. When the strike ended, support among workers for unions increased, and the Knights of Labor's membership rolls swelled.[60]

By 1884, the Knights boasted 700,000 members. Their power across state and city lines was not harnessed effectively as a tool for job action. But in various local assemblies, progress was made. The group's strike against the Wabash Railroad, owned by industrial magnate Jay Gould, won unexpected and unprecedented success. When a Knights member in Marshall, Texas, was fired from his railroad job for attending a labor meeting on company time, the organization locked horns with Gould again, during the great

southwestern railroad strike of 1886. The effort was a failure on the larger scale, due to violence, Gould's use of scabs on a widespread basis and government troops, among other reasons. Knights of Labor members—over Powderly's objections—participated that same year in a huge labor rally at Haymarket Square in Chicago, an incident that degenerated into an infamous riot. The involvement of KOL membership in the violence, even though it was not sanctioned by the organization's leader, tarnished its reputation.[61] The nation as a whole took a dimmer view than ever of organized labor. The KOL continued its operations, however, organizing railroad workers in several Louisiana towns, including Schriever, a railroad hub for passengers and freight to and from Texas and New Orleans. Tracks branched to the smaller bayou country towns like Thibodaux and Houma. District Council 8404 of the KOL included the railroad men from Schriever. As was the custom, the KOL membership was not limited, and in 1885, men who were deeply involved with sugar harvesting and growing—almost all of whom were black—declared allegiance to the KOL's principles. Demands brought to the sugar planters were summarily dismissed year after year, and frustration continued. With a national labor organization backing them up, community activists in Thibodaux, Houma and other sugar belt communities were emboldened. A strike, not just of one or two plantations but of the entire region, some reasoned, could have a major effect on the living and wage conditions of sugar workers.

Organized labor had come to the sugar country on a scale the planters could never have imagined.

Big planters in the sugar region, like the Minors at Southdown, were exceptions rather than the norm. Both faced the same adversities, however. Except for cases where mismanagement or a quirk of fate—a burned sugar house, for example—befell

Sugar cane laborers, possibly taken shortly after the Civil War. *New York Public Library.*

a particular planter, what plagued one plagued all. Weather patterns were democratic in their wrath when working against the planters. Droughts were regional, as were early frosts. If planters had learned anything in Louisiana from the time of Bienville, it was that they grew a crop inherently delicate. Native to the tropics as it was, cane succeeded in such climes because the weather was so ideal. The cane could tolerate fickle south Louisiana weather but had to be carefully coaxed if it was to thrive. During the 1883 to 1884 season, Louisiana's total cane harvest exceeded stalks from 172,000 acres, yielding 128,000 robust tons. The next year, rampant flooding decimated planters, resulting in a yield of 94,000 tons. The more land a planter worked, the more individual hands there were to be paid, and their families needed to be fed.[62] "The sugar houses, as the factories were then called, were rather small affairs strung along the bayous every two miles or so," wrote labor organizer and poet Covington Hall in his memoir, recalling his teen years. "Their three-roller crushers seldom exceeded four feet in length, and a few were still turned by horse power." Although planters in Lafourche Parish were not the target of worker uprisings during the strike of 1874, they readily agreed to pay the same lower wages proposed by the Houma sugar growers. Likewise, in the farther reaches of Terrebonne Parish itself, smaller operations in communities like Tigerville also fell in line. But such planter solidarity was often achieved only in troubled times.[63]

Leaders of the Terrebonne strike back in 1874 had been in touch with Knights of Labor organizers in 1885 and 1886. Hamp Keys, the firebrand Houma legislator, and William Kennedy, a former Terrebonne Parish sheriff, had in the years since their political heydays gone back to laboring on sugar plantations. They were part of a sugar belt progressive elite that used the presence of KOL organizers in Schriever to determine how long-standing complaints of the laborers could be addressed. By the mid-1880s, a new intellectual elite had emerged in the sugar parishes. There are no known records linking Benjamin Lewis to the Knights of Labor, but he was teaching school in Terrebonne Parish during that period, and there is reason to believe that his ties to men like Keys would have remained strong.[64] Another schoolteacher, Junius Bailey, was clearly involved. Whether his path ever crossed those of Lewis or Murrell is a question still unanswered by historians. That he may have been inspired by either or both is likely. He was born a slave in Assumption Parish on November 25, 1857, though it is not known on which plantation or in which household. His mother, Clara Jones, was said to have been a direct descendant of U.S. Navy hero John Paul Jones; his father, James, was from

Young sugar cane in a field near Schriever, Louisiana. *James Loiselle.*

Madagascar and died when the boy was only six years old. Details are sketchy, but one biographical entry states that young Junius made his way from Assumption to Pointe Coupee Parish, where he "nearly drowned" in an 1866 flood. He attended Leland University, a black Baptist college in New Orleans, making his way to Lafourche after his 1877 graduation. By 1878, Bailey was active in Republican politics, despite a severe attack of yellow fever during a fearsome epidemic that swept through the lower part of the state.[65]

Bailey served as a teacher on several plantation schools organized for black children, the one on Thibodaux's Laurel Valley Plantation reportedly among them. His education and skill at public speaking placed him in a unique position. One of the Thibodaux black masonic lodge's founding members, Bailey engineered the sale of local plantation property for the lodge's first headquarters, in 1884.[66] While Terrence Powderly had stripped much of the secret symbolism built into the Knights of Labor, the group still maintained elements that were reflective of masonic secrecy. Richard Adams, worshipful master of Thibodaux's St. Joseph Lodge in 2016, noted in an interview for this book that there were few places in the 1880s where black men could meet without watchful eyes upon them or prying ears determining what their conversations were

A statue of CSA general P.G.T. Beauregard at the entrance to City Park in New Orleans, one of four statues tagged for removal as public nuisances by the New Orleans City Council in 2016. *James Loiselle.*

about. Masons could meet legally and freely. Emmanuel Banks Christian Sr., a highly respected educator, was also affiliated with the Knights of Labor. Christian lived in Mechanicville, a community slightly south and east of Houma and now within its city limits. Well known for his literary background, Christian was enamored of the works of Whittier, Longfellow and Alfred Lord Tennyson. But he also knew sugar, occasionally signing on as a laborer during rolling season at local plantations.[67] While the Masons in Thibodaux were breathing life into their fledgling lodge, white supremacists in New Orleans had put finishing touches on a lasting memorial to the lost cause of the Confederacy, in some cases with support from planters in Terrebonne and Lafourche. The "cult of the lost cause" resulted in later monuments to Beauregard, Robert E. Lee and the Battle of Liberty Place in the Crescent City.

The argument could certainly be made that conditions on the sugar country's plantations represented a living embodiment of the "lost cause," which activists like Bailey and Christian sought to upend. The organizers were familiar with the frustrations the plantation system presented for workers, how easily cash wages were eaten up by necessities and how

The slave quarters on the Laurel Valley Plantation in Thibodaux, where workers paid wages after the Civil War continued to live. Former slave quarters like this throughout Lafourche and Terrebonne were the homes from which workers were evicted during the 1887 strike. *James Loiselle.*

invisible economic oppression resulted in the same end as tangible iron chains. Payment was often made in scrip—pasteboard commissary notes redeemable for goods at stores operated by the plantations themselves—instead of cash. With little ability to travel, workers remained bound to plantations with no hope of better lives for themselves or their children. The cabins so many occupied on plantation grounds were as much quasi-prisons as they were homes.

Support for the sugar industry and its practices extended beyond the mansions its workers helped maintain. Businesses that grew up around the sugar belt to serve the industry were booming. Ozeme Naquin, the owner of the Thibodaux Boiler Works, employed eighteen people, turning out as many as thirty boilers per year. Boilers were as necessary to sugar processing as they were to steam locomotives. Strong boilers needed strong iron, as did other aspects of sugar cane infrastructure. But mechanical failure was always a possibility, and crews of mechanics were dependent on the plantations for their continued employment. The presence of the traveling mechanics was cited in annual reports of Thibodaux's well-being and the suggestion that happy times were on the horizon.

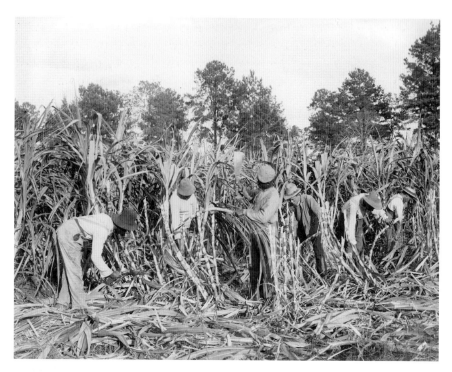

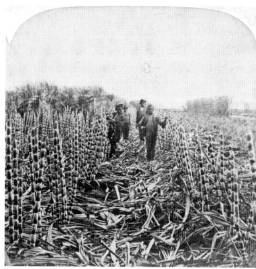

Above: Sugar cane workers performed grueling labor on plantations before and after the Civil War in Louisiana. *Library of Congress.*

Left: Cane workers in a Louisiana field. *New York Public Library.*

"There are two gangs of mechanics now engaged on sugar plantations in the making of repairs," one account states. "Mr. Naquin congratulates himself deservedly on having had a very prosperous season of it the

present year. The boilers were huge, twenty-eight feet long, generally."[68] Another business owner whose success was tied to that of the planters was Lawrence Keefe, owner of Thibodaux's foundry on Levee Street, described in one essay of the time as "the most important industry in the town." "This establishment employs eighteen hands year round, and has work on hand nearly all the time. This season, owing to the fine crop of last year, the foundry has been worked to its utmost capacity," a magazine piece states.[69] Serving Lafourche, Terrebonne and St. Mary planters, the foundry and the boiler works, along with other ancillary businesses, had as much at stake in the success of the sugar crop as the planters themselves. It was weather, at first, that threatened the livelihoods of those engaged in these interrelated businesses. The threat from organized labor would not be far behind.

By all appearances, Jack Conrad's return to the Caillouet plantation after the war was uneventful, despite his decision to join up with the bluecoats. He married a woman named Mary. Although born in Kentucky, Mary, like Jack, had grown up on the Caillouet place. They made a home in the former slave quarters, and their first child, a girl named Clarisse, was born within the year. Clarisse's given name is the same as that of Jacques Caillouet's second wife, and it is possible that Jack named the child after her. He would have known her from the time of his birth, and it could be that she was particularly kind. In 1868, their second child was born, a boy named Grant. Baby Grant appears to have had a namesake as well. As was the custom with a number of black Civil War veterans on the Federal side, Grant may well have been named after Ulysses S. Grant, hero general who later became president.

While many sugar workers appeared willing to organize, others did not. By 1880, Jack Conrad and his wife, Mary, had three children, with a boy named Manfred, or Manford, born in 1878. Young Grant Conrad was twelve years old in 1880 and already working in the fields. After the first half of the decade, Conrad's fortunes changed. "We lived on Mr. [Caillouet]'s plantation until 1886," he told an interviewer. "I then moved into the village of Thibodaux, where I lived for about one year…I was working for Captain [N.W.] Whitehead, who had a sugar plantation about four miles from Thibodaux. I was manning an engine for him." As an engineer, Conrad's wages were higher than those paid to field hands. His son Grant, by then eighteen years old, continued working in the fields as a laborer. Whitehead, who served in the Fourth Louisiana during the war, was an officer in the reorganized Louisiana State Militia in Lafourche, owner of Abbey Plantation just north of Thibodaux.

The Thibodaux Massacre

While young Grant was believed to have joined the Knights of Labor, Jack declined. Accounts from the time of the strike indicate that workers whose duties did not involve toiling in the fields were less supportive of the strike. The fight of the field hands was not their own. But as Jack Conrad would later learn, planters and their white supporters might not have realized this.[70]

5
SEEDS OF REVOLT

Despite the rigors of January and February, the year 1886 began on a positive note for John Jackson Shaffer, who operated Magnolia Plantation on the northern end of Terrebonne Parish. The son of William Alexander Shaffer, the justice of the peace planter who required marriage for his slaves, John Jackson was a man of strong opinions who had earned a reputation for being a leader during the war. He survived imprisonment by the Yankees after the siege at Vicksburg, where he commanded infantrymen of the Twenty-Sixth Louisiana's Company F. Even then, more than twenty years after the war's end, Shaffer was referred to by other veterans in Terrebonne Parish as "Captain."

He spent part of May that year painting the house, which he had purchased in 1874 from a New Orleans bank. Named for the many flowered trees that graced the property, Magnolia was a mainstay of planter society after its construction by the slaves of founder Richard Ellis in 1834. Within its walls, Braxton Bragg, at the time a colonel, married Eliza Brooks Ellis, the planter's daughter, in 1849. The modified Greek Revival house was used as a Federal army hospital during the war. While so occupied, Union soldiers hauled the manor's grand piano out to the yard, unceremoniously removed its innards and then converted it into a feed trough for Federal horses.

John Jackson and his father restored the home to something approaching its former dignity, preserving its magnificent winding staircase of solid rosewood and other appointments. Shaffer had the best in mechanical equipment, including a thirty-four-foot boiler built by Ozeme Naquin.

But as 1886 drew to a close, John Jackson bitterly noted the damage an early winter had done to his crop. Living, as did other planters, year to year, there is no doubt that such setbacks were painfully felt.

"The cane is all frozen in the field," he wrote in a diary entry on December 6, noting one month later that the weather was "very cold, everything frozen still."

Weather records from the time show that in December, temperatures had plummeted to twenty-two degrees.

"The winter of 1886 was very severe, destroying much of the seed and stubble, the spring was late and cold, and good stands of cane were not obtained till May," the Louisiana Sugar Planter and Manufacturer's record of the region states for that year.

The new year, 1887, remained colder than usual, with temperatures reaching a more merciful but no more comforting twenty-six degrees.

"Very cold, everything frozen solid," John Jackson Shaffer wrote on January 5, noting a few days later that stores were running low with "some negroes out of supplies."

On January 8, a day that was "damp and disagreeable," John Jackson rode to Houma, stopping on his way down Bayou Black to visit William

Magnolia Plantation in Schriever, now a private residence, where planter John Jackson Shaffer was overwhelmed by strikers in 1887, causing him to ask for help from Governor Samuel McEnery. *James Loiselle.*

Alexander Shaffer, his severely ailing eighty-nine-year-old father, at Crescent Farm. The Louisiana Sugar Planters Association, whose meeting he had attended, discussed the issue of wages and what the disastrous 1886 season portended for the 1887 crop. "Nothing definitive" was discussed, according to John Jackson Shaffer's diary entry.[71]

While Shaffer worried over his crops and his ill father, the Knights of Labor were digesting rumors that the poor crop would result in a rollback of wages. Although the organization had lost credibility and power nationally by 1887, it appeared to be thriving in its Bayou State stomping grounds. There were twelve different assemblies of the Knights in New Orleans. In the Teche region, west of Terrebonne, one assembly was estimated to have five thousand members. In Ascension and Lafourche, there were three assemblies, at least one composed of black field workers, although the membership numbers are not known. The KOL's Louisiana assemblies were in no way limited to sugar cane workers. If they were being paid a wage for labor, they were eligible, men or women, black or white.[72]

Whether a group of men who fanned out in Lafourche Parish well south of Thibodaux in early 1887 was of the KOL or not cannot be proved.

But there are documented instances of wide-ranging, mass walkouts as early as January.

Raceland is a small, central Lafourche Parish town, located on the bayou's banks about midway between Cut Off and Thibodaux. Owing to its population of subsistence fishermen and farmers in the nineteenth century, the lower Lafourche plantations employed more white workers than some others in the region, though most of those were not full time. They tended to work sugar during peak portions of the season, when labor was needed most, returning to trapping or fishing when the work was done. The bulk of the labor force was black, and for full-

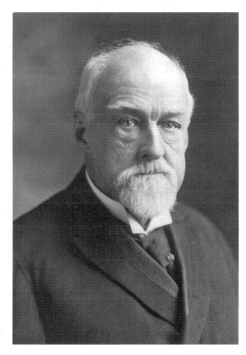

Governor Samuel McEnery. *Library of Congress.*

time workers at these smaller plantations, such as Mary and Ravenswood, the wage was around sixty cents per day. Raceland was a gateway to the bayou communities that stretched all the way south to Grand Isle, and the general store operated there by merchant Simon Abraham was a center of gossip, news and commerce. Abraham, a native of France, was well versed in the languages of both his homeland and his adopted country. Groceries, dry goods and clothing were among the items in which Abraham did trade. He was also the Raceland postmaster. The store was not far from the railroad depot, whose cars regularly shuttled to Thibodaux and back.

On the morning of January 19, sixteen black men gathered on the Bayou Lafourche levee just below Abraham's store. One of their leaders was a man named Peter Young and the other Amos Johnson. The men headed southward and were observed on the levee by Richard Foret, owner of the 1,800-acre Mary Plantation. His account, and those of others who witnessed what occurred next, is taken from Lafourche Parish court transcripts.

"I came up to Raceland to take the cars to come to Thibodaux on business," Foret said. Upon arriving at the depot, Foret was approached by a young man named Nicolas Sevin, who told him the strangers were headed for his plantation.

"I saw the crowd going down and heard them say they were going down to Mary Plantation and would see if the hands were working, and if they

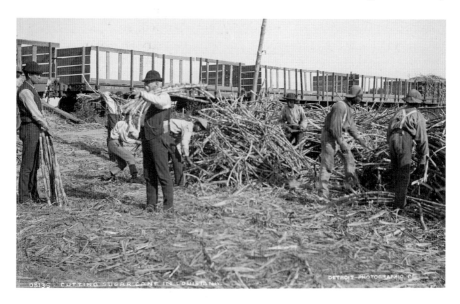

Sugar cane workers load stalks of cane at a Louisiana plantation under the supervision of an overseer. *National Archives.*

were working they would prevent them from working…if it was possible," Sevin said.

Although concerned about the possibility that his laborers would be interfered with, Foret could not alter his travel plans, so he went to Abraham's store for assistance.

"I…asked him to send one of his clerks down to notify my assistant overseer of it," Foret said.

Abraham obliged and sent a clerk, Henry Brown, who arrived at Foret's after the visitors got there.

"I went immediately to the field and saw sixteen men there from Raceland," Brown recalled. "I told the boys on Mary Plantation to keep on working, but they said no. The men who had been there said if they didn't stop, they would come back and run them out of the field."

Brown recognized Peter Young.

"I saw him there," Brown said. "I took the names of twelve of them out in the field. …The others, I did not remember their names."

At noon, the workers at Mary Plantation heeded the warnings and halted work.

"The Foret hands agreed at once to stop," said Lewis Anderson, a worker from a neighboring plantation.

When questioned by authorities, Amos Johnson acknowledged that he was with the crowd but told authorities upon later questioning that he remained on the levee with Peter Young and that neither of them went "to the quarters" with the other men to talk with the Mary Plantation workers.[73]

When and how the laborers returned to work on Richard Foret's plantation is a matter lost to history. That their departure, however brief, was taken seriously by Foret—and the authorities—is not. A complaint was sworn out by Foret against Peter Young, along with Jordan Brannon, Prescoe Wheeler, Johnny Phillips, William Pearson, James Lagarde and "ten other persons whose names are to him unknown." The charge was unlawful assembly, and the information—an accusatory instrument similar to an indictment—is shrill in its description.

The defendants "did unlawfully, rioutously and routously assembled together…and being so assembled, to the horror and disturbance of the laborers on the Mary place…maliciously and unlawfully threatened to do harm to the said laborers and use violence against them if they did not at once quit to work."

Peter Young was tried the next day; the trial's transcript provided the remaining accounts of what occurred. The record of what penalties

were assessed and what became of the other defendants in that case no longer exists.

What the record does show is that the authorities took an additional step. On February 25, Amos Johnson was charged with perjury for his statement under oath that he did not go to the Foret plantation with the others.[74]

If the planters of Lafourche had any indication that the troubles on Foret's place were merely a portent of more critical problems to come later in the year, they gave no overt signs of such. But then, neither did the labor activists. A brief letter to the Knights of Labor's official publication, the *Journal of United Labor*, presented an optimistic picture.

"The average pay for work in this vicinity is 65 cents per day for first class and 50 cents for second class men," W. Weber of Local Assembly 8404 in Schriever wrote on March 26. "Work is plenty and workers moderately so. There is a good crop prospect. We expect an increase in wages by April 1."[75]

At least three of the men charged in connection with the walkout on Foret's plantation were originally from St. Mary Parish, which was to become the Fort Sumter of the burgeoning sugar war. Located west of Terrebonne Parish, St. Mary bears a significant geographic difference from Terrebonne and Lafourche, as its greatest ecological influence is the Atchafalaya River.

Closest to Terrebonne is Morgan City, a port town near the mouth of the Atchafalaya. It was originally called Chénière au Tigre—or Tiger Island—in an early survey, although it is not an island and contains no tigers. It was the first European settlement in St. Mary and acquired the name of Brashear after a pioneering planter. Its strategic location on the Gulf resulted in considerable action during the war. A widening of its channel and other improvements by railroad and steamship tycoon Charles Morgan resulted in yet another new name, the one it has enjoyed since 1876. West of Morgan City is a town called Berwick and another called Patterson, referred to as Pattersonville in 1887. West of Pattersonville is Franklin, the parish seat, which has a total of eighty-six miles between it and Morgan City, most of it rich with broad fields of cane. With its diverse population and multi-modal transportation, St. Mary was a natural for organization by the Knights of Labor, which established seven local assemblies within its boundaries. The first of those, in Morgan City, was established in 1886.[76]

Although the locals were racially segregated, they worked closely together, their members seeking to best the power that Charles Morgan wielded. But ripe for organizing were the sugar laborers as well. By the start of 1887, the seven local assemblies boasted between 100 and 150 members each. The Morgan City assemblies' association with railroad workers—and the fledgling local

A St. Mary Parish cabin, similar to the one where strikers were shot in 1887 in the weeks leading up to the Thibodaux Massacre. *Library of Congress.*

assembly in Schriever made up of railroad men—provided the potential for support if a sugar strike was necessary, as KOL leaders planned their regional push for elimination of scrip as payment, as well as wage increases.

While laborers met, largely in secret, the sugar planters were making preparations for the potential of labor action. The Louisiana Sugar Planters Association, based in New Orleans, had branches in St. Mary, Lafourche and Terrebonne. Indications to the planters would have been that labor actions, as had always been the case, would more likely occur after the 1887 crop was brought in. The year's crop was crucial, considering how bad things had been the previous year.

A yellow fever scare, and not a labor action, was what prompted violence and resulting protest from blacks in an incident that occurred on one St. Mary Parish plantation during the summer. Not known to have any relation to labor complaints, the shooting of an unnamed black man on H.N. Pharr's Fairview Plantation in Berwick could not have done much to improve relations between workers and management in the months to come.

"There was another yellow fever epidemic this year," begins the item in the Morgan City archives whose author is not attributed. Because of this, the narrative states, Pharr "would not allow traffic from Berwick into Fairview."

Security was maintained by a watchman working for Pharr, described as an "old Tennessean." The account of the incident gives harsh clues to the esteem in which some white residents held their black neighbors. It is notable for its reference to the KOL.

"It was Sunday morning and as usual all the negroes in Berwick were drunk," the narrative reads.

> One of them was a little bolder than usual and tried to cross the line. The old man told him that if he did he'd shoot him. Besides being drunk these negroes felt unusually important because of their organization called the Knights of Labor, of which they were members. This negro decided the threat was merely a bluff and crossed the line, whereupon the old [guard] shot him. This started things. The negroes got very excited and bold and began to make for the old man. Outnumbered and not wishing to kill more of them he retreated to Fairview and reported it to [Pharr]. The family was in the midst of dinner but this man upset the meal a good deal, because they realized what the negroes might do when drunk and especially as they were cut off from outside white aid.[77]

Pharr was among the planters who engaged in direct dialogue with the Knights of Labor in August 1887. The district assembly, which included worker representatives of nearly all the sugar parishes, communicated with the St. Mary chapter of the Louisiana Sugar Planters Association. The statement of objectives was worded more as a request, although the subtext was more onerous.

The August 22 missive, addressed to the LSPA office in Franklin, says the labor organization

> would be pleased at any time or place prior to the grinding season to meet with a committee appointed by your association to make some amicable arrangement of a question in which both planters and laborers are equally interested.
>
> The probability of the coming grinding being the most prosperous of any experienced for several years by this parish, and any misunderstanding between employer and employee at such a time would be of incalculable injury to the prosperity of planters and laborers and the public of the parish in general, therefore this board in behalf of the labor acknowledging its actions, would earnestly request that your association appoint a committee of ten with equal powers as this board to meet as aforesaid.

The letter was signed by the District Assembly secretary, B.W. Scott. A response was tendered from the planters through their secretary, John O'Neill.

"I have no reply to make to your communication of Aug. 22," the response states. "As a matter of courtesy and politeness, however, I write to say that your letter was read and discussed in executive session and by a unanimous vote of the members present it was laid on the table."[78]

In other words, the request would receive no further consideration.

The Knights continued organizing and, by October, had developed a firm game plan. The district council met on October 19 to discuss the terms and conditions that would be presented to the planters. It included a mention of pay for night watch—the duty some laborers would be given in addition to their regular work—but with minimal compensation, referred to in the industry generally as simply "watch."

The KOL communiqué is significant because of its discussion of wage increases relative to the coming grinding season. In the past, laborers complained or negotiated around less sensitive time frames, so negotiating before harvest would have put pressure on the planters to resolve the laborers' issues quickly to avoid hurting their profits. The communiqué mentions a total of five parishes: Lafourche, Terrebonne, St. Mary, Iberia and St. Martin. It also specifically addresses the laborers' displeasure at being paid in scrip and requests that wages to be increased from $0.65 to $1.25 per day without board—for day workers living off of plantation grounds—and $1.00 per day for those living on site. Watch would be compensated at $0.60 per shift with "no pasteboard to be accepted in compensation for labor." The group also demanded watch money be paid every week and regular wages every two weeks.

"[Should] this demand be considered exorbitant by the sugar planters," the missive reads, "we ask them to submit such information with reason therewith to this board not later than Saturday, Oct. 29…or appoint a special committee to confer with this board on said date."[79]

The demand was written by Junius Bailey, president of the Knights of Labor local in Schriever, the former boy slave who had become a teacher.

Although the deadline was October 29, the available record indicates that the strike activity began well before that, at least in Terrebonne Parish, likely the twenty-fourth or twenty-fifth.

Organizers appointed committees of three workers on each of the Terrebonne plantations and ensured that at least one of each could read and write. Those representatives beseeched each individual plantation owner to accede to the demands of higher wages and elimination of scrip. The receptions they received were cold.

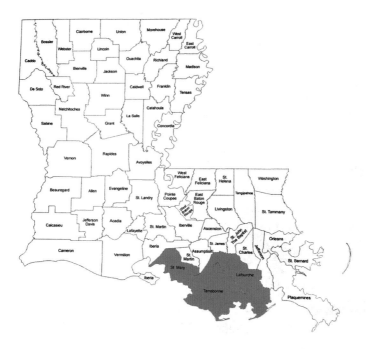

The shaded area shows St. Mary, Terrebonne and Lafourche Parishes. *Louisiana Department of Culture, Recreation and Tourism.*

"The planters, on their side, paid no attention to the circulars and messages, leaving it optional with the negroes to work or not," a newspaper account states. "On many places the negroes struck and the plantation continued its operations short-handed and it was not long before the negroes returned to work."[80]

At Magnolia Plantation, John Jackson Shaffer tried to contend with a work stoppage, pleading along with his overseers for hands to return to work, but to no avail. The sheriff was called, in an attempt to order workers back, but—perhaps due to the understanding that a bigger effort was underway—the strikers paid scant attention. By October 26, still standing firm in his refusal to accede to worker demands, Shaffer gazed upon acres of cane prime for harvesting, placed at risk of ruin.

On October 27, Governor McEnery received an urgent telegram in Baton Rouge.

"My plantation is in the hands of a mob of strikers; all willing to work were driven away by the mob. Everything is paralyzed," it read. "The parish authorities are inadequate. I invoke your authority immediately. –J.J. Shaffer."[81]

6
BATTLE LINES

John Jackson Shaffer was not the only planter seeking help from Governor McEnery. North and west of Shaffer's place lay Tigerville, today called Gibson, a thriving lumber town that boasted successful sugar plantations on the banks of Bayou Black. One of those plantations, Greenwood, was acquired only a year or so earlier by Laurent Lacassaigne, a native of France, who for years had operated a highly successful mercantile firm in New Orleans.

About sixty workers were bringing in the harvest on Lacassaigne's place, twenty-five of whom were white. The black workers struck, but the white hands kept working, with Lacassaigne making arrangements for replacements to be sent from New Orleans. All forty-five of the replacement workers were white. Strikers ambushed the workers, firing at four of them, and the frantic planter wired McEnery for assistance. The replacement workers left the plantation and returned to New Orleans.

McEnery indeed acted swiftly, contacting Colonel T.A. Faries, assistant adjutant general of the Louisiana National Guard, second under Adjutant General P.G.T. Beauregard.

"The Terrebonne Strike has unnecessarily assumed a shape that is considered dangerous to life and property, and in order to support the civil authorities in their efforts to preserve peace, the Governor has upon an urgent request, ordered that a detachment of troops be sent to the parish...deemed necessary to prevent serious troubles," reads an order from the state's Executive Department. "Send a detachment of troops, if practicable, from the St. Mary

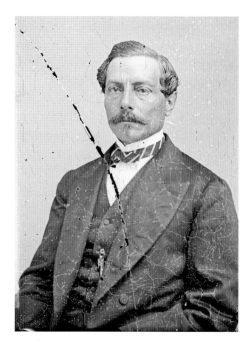

P.G.T. Beauregard was adjutant general of the Louisiana State Militia in 1887 and dispatched troops to Thibodaux at the request of Governor Samuel McEnery. *Library of Congress.*

volunteers, or from companies at New Orleans, with new Gatlin gun from New Orleans."

In a separate dispatch to Colonel Faries, McEnery wrote, "Act promptly and vigorously upon orders just sent you."[82]

With as much speed as the technology of the day would allow, state militiamen mobilized for deployment in the sugar country. Cognizant that military backup was on the way, planters met in Thibodaux to determine their next move. Judge Taylor Beattie joined Emmanuel A. O'Sullivan, the district attorney who had prosecuted cases relating to the disturbance on the Mary Plantation, in leading a mass meeting of sugar planters on October 30. With the approval of the planters, they drafted a resolution of their joint position.

Without referring to the Knights of Labor by name, the resolution maintained that "a committee of people claiming to represent a secret organization have called upon the planters of Lafourche to accede to certain demands as to the rate of wages and manner of payment."

Maintaining that the "secret organization" would not only halt working but also prevent others from doing so "by force," the planters pledged themselves "one and all to meet this trouble as good men and law-abiding citizens, and that to that end we hereby tender ourselves to the sheriff and other constituted authorities to obey any and all calls upon us to assist in carrying out the law, and that our names be at once furnished to the sheriff that he may call upon us in the event of necessity for our services."

The depressed condition of the sugar business, the planters said, forced them to refuse consideration of any wage increases. They further refused to "in any way recognize the body of men who have represented themselves as a committee appointed by a secret organization."

They invited all citizens, "regardless of race or color," to join in "carrying out the plain behests of the written law of the land."

The planters agreed that if any laborers were to be discharged from a plantation where they worked, or if they refused to work, they would "give them no employment."

All people discharged for refusal to work would be required to leave the plantation within twenty-four hours, "and on refusal to obey that the powers of the law be involved to assist the owners of property in their enjoyment of their rights of property." The resolution also formally declared that a state of emergency had arisen, requiring military intervention by the governor "to prevent bloodshed and violence." The parish sheriff, the resolution states, was empowered to call on the governor for the aid of "some recognized military organization."[83]

A meeting in St. Mary Parish resulted in a similar resolution, with the added support of a white Knights of Labor local, which disavowed the district assembly's support of a strike scheduled to begin on November 1. A planter from the St. Mary Parish town of Jeanerette, F.M. Welch, had already traveled to Vicksburg, Mississippi, to secure "negroes to take the places of the striking cutters." A railroad car full of Welch's strikebreakers pulled into the station at New Orleans, where he told a Picayune reporter that he would have no problem securing further labor from Mississippi to break the strike.[84]

On some Lafourche Parish locations, planters attempted to make good on their word to take action even before the militia arrived. At the plantation of Judge Edward Douglass White —who, a decade later, would be named to the U.S. Supreme Court and eventually become its chief justice—all hands stopped work on October 31. They were quickly charged with trespass and arrested by Sheriff Theophile Thibodaux, who had defeated Junius Bailey in the 1884 election. A deputy named Frost assisted, and most of the strikers left for downtown Thibodaux. Two workers—John Ballard and Phillip Dixon—remained at the White plantation and were taken into custody, their bonds of $100 put up by other black men.[85]

Many newspapers of the 1880s took little care to even pretend objectivity, and the mainstream New Orleans dailies were no exception. The November 2 *New Orleans Daily Picayune* described early strikers on the Rienzi plantation in Thibodaux as "the most vicious and unruly set of negroes." The newspaper also made a record of the determination strikers displayed. A reporter wrote that a worker told him, "No power on earth could remove them unless they were removed as corpses."

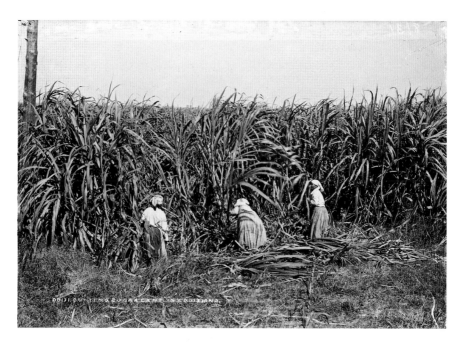

Women cutting cane in a Louisiana field. Women and children commonly worked the fields before and after the Civil War. *New York Public Library.*

The Rienzi laborers were told that the militia would soon arrive and that they would then be summarily evicted.

"One of the leaders of the strikers said…that the white people had never met the negroes united before, that they had heretofore been disorganized when unjust demands were made them by the whites," the *Picayune* story reads. "Now, he said, they defied all of the militia of the state, they were right, he thought, in this movement, and every one of his four hundred members would die before they would concede one point to the planters."

The *Picayune*, noting that a meeting of the strikers was scheduled for that night, opined, "A great deal of whiskey-drinking has been going on among them all day, and maddened by drink and defeat, it is feared that they will attempt devilment before daylight."

Among the local organizers were two black brothers, George and Henry Cox, who drew newspaper attention. Henry Cox told a *Picayune* reporter that his instructions were to seek peace and prevent violence, which the newspaper reported, adding, "That is what he is saying to outsiders, but it is generally believed that he is doing more incendiary work than anyone else."

In at least one instance at this early stage in the strike, there was evidence that strikers damaged property in Lafourche. Growing cane was set afire

in the fields of Clotilda Plantation near Lockport. Owned by John Lyall and J. Lovincy Leblanc, Clotilda was one of the smaller Lafourche Parish farms, but large by Lockport standards, located not far from Richard Foret's plantation, where trouble had ensued at the start of the year. Workers William Washington and Thomas Savage were charged with starting the fire but later acquitted.[86]

While Lyall and LeBlanc's remaining workers struggled to contain the cane fire, a detachment of state militia under the command of Captain W.H. Benham arrived at the Schriever train station. With their horses and a .45-caliber Gatling gun in tow, they were prepared to restore order at J.J. Shaffer's Magnolia Plantation and other farms requiring assistance. The authority of the troops was limited, their orders directing that they act "only in case of riot or breach of the peace…to prevent any attack or interference with men who are willing to work."

In case of further trouble, the orders stated, ranking officers were authorized "to order as many troops from different points" as might be needed.

Four companies detrained altogether.[87]

Told that similar disturbances would soon occur in Lafourche, St. Mary and Iberia, with a possible shutdown in all sugar-producing parishes, General J.R. Parkerson, of the Fourth Military District at Franklin, was directed to wire the commanding officers of his six companies to ready for deployment. State militia from Baton Rouge and Ascension Parish were also put on readiness alerts.

In Schriever, however, the Terrebonne district court judge, A.C. Allen, communicated to military authorities that peace was restored at Magnolia. The violence at Tigerville had quieted matters in that parish generally. Rumors—later found to be unsubstantiated—that the shooting at Tigerville resulted in the deaths of four white men made their way from parish to parish through misinformed newspaper dispatches and panicked telegrams. Armed forces were moved between parishes, and the general belief was that the region as a whole was on the brink of war with and within itself. Benham and his men, two lieutenants and twenty-one enlisted, received orders to move on to Thibodaux. Like other officers of the state militia, along with many members of the local guard, Benham was a Civil War veteran. A native of New Orleans, he had served in a Crescent City unit called Greenleaf's Light Cavalry, which had been incorporated into the Army of Tennessee. The unit served as an escort to General Leonidas Polk.

Another Civil War veteran was on the train as well. William Pierce of the serenading, dapperly uniformed Continental Guard had been made a

Railroads like this one carried troops to Thibodaux in 1887 and carried people fleeing the violence to the train station in Schriever, where they transferred to trains heading to New Orleans. The people referred to the trains as "the cars." *New York Public Library.*

brigadier general in the state militia and was its quartermaster. En route to Thibodaux, Pierce, Benham and their armies passed plantations and fields, getting a bird's-eye view of the situation they had been called to deal with.[88]

"I saw the fields in all directions full of cane, the mills idle, the stock and carts and wagons laid by and no work being done except on a few places, where planters had acceded to the demands of the strikers and some half dozen places where, for some reasons, the hands were still working at the old rates," Pierce remarked in a later report to superiors. "I was informed that had been the state of affairs for three or four days. I noticed at Schriever a very large body of negroes lounging around the depot…impudent and offensive."

As the train steamed into Thibodaux, Pierce noted the presence of many "idle negroes," remarking that the streets were "full of them."[89]

At 4:00 p.m., the troops had reached their destination, a depot not far from the courthouse, at its terminus a short walk from Bayou Lafourche. The officers and men were met by Judge Beattie, who told them that Lieutenant Governor Clay Knobloch, a local planter like himself, had already activated the Lafourche militia, which he commanded. Knobloch's men, one lieutenant and twenty-three enlisted, were quartered in the courthouse.

Along with Beattie, a crowd of citizens opposed to the strike was at the station. The troops were also closely watched by an estimated two thousand strikers as they removed the Gatling gun from the train, harnessed it to a team of horses and then bore it up the steps of the courthouse, where it remained displayed. A twelve-pound Napoleon cannon was also deployed in front of the nearby jail. Upon his arrival, Pierce took receipt of a cable, ordering him to take charge of all state militia units from the Mississippi River to St. Mary Parish's Berwick Bay. During a briefing from Beattie and other planters, Pierce learned that "the workers on the plantations, nearly all negroes, men women and children, had demanded an increase in wages"; that the demands had been rejected by the planters; and that the laborers living on plantation-owned cabins and rooming houses were told to leave if they would not work. The laborers had refused to do so.

"New labor could not be brought in for two reasons," Pierce wrote in his report on the situation. "The strikers would not let them come and there was no place to house them, if they could have been taken to the plantations." The black people gathered at the courthouse square and visible throughout the town "would leave the surrounding plantations and walk into the towns, where they would loiter all day and return to their cabins on the farms at night."

The Schriever train station, now used by Amtrak, where state militia arrived from New Orleans to aid planters in breaking the 1887 strike. *James Loiselle.*

Beattie told Pierce that the Planter's Association would provide food, as well quarters, for the troops. The state, he was assured, "would be put through as little expense possible during the continuation of the strike and the stay of the military."[90]

As the soldiers stacked their guns and went over billeting plans with their lieutenants, Pierce and Benham communicated further with Beattie. The judge said he would issue warrants the next day for the eviction of strikers. Pierce continued making plans with him after nightfall, coordinating the placement of guards outside the courthouse. More trouble, meanwhile, erupted in Houma, and Pierce ordered a company from New Iberia that was awaiting instructions at Schriever to take a train there. Plans to break the multi-parish strike, using Louisiana's official militia as enforcers, began.

"Serious trouble is then expected all over the country," the November 2 *Picayune* reported, "as the negroes generally are stubborn and disposed to stand their ground."

Part III
A PAGE TORN FROM HISTORY

7

VIOLENCE AND THREATS

The next morning, November 2, General Pierce and Judge Beattie met again at the courthouse. Sensing the great tension that prevailed, the general ordered that the teams of horses be harnessed and ready, if need be, to transport the Gatling gun and the twelve-pounder wherever they might need to be deployed. Hundreds of men and no fewer than a half dozen artillery pieces were stationed at a variety of points in Terrebonne and Lafourche. At Houma, local authorities and troops from the New Iberia guards rounded up seventeen men believed responsible for the shooting incident on Greenwood Plantation, and they were jailed. The troops, with Terrebonne deputies, then moved on to Schriever, where, according to one military report, trouble had erupted on the Waubun Plantation, a short distance from Magnolia.

"An order was given five days ago to five evil disposed negroes refusing to work or to permit others to work, to remove off the place, four days notice having been given," the report, republished in the *New Orleans Democrat*, reads. "Refusing to obey this order, and obstinately persisting in defiance of law, Judge Allen ordered the sheriff to proceed with Capt. Avery's company at once to evict the five turbulent negroes. He arrived at the place at 10 o'clock. The eviction was caused by the sheriff without the least resistance whatever."

Within a short time, double the hands who had been at Waubun were at work bringing in the crop.

"The backbone of the strike in this parish is generally conceded as broken," a dispatch in the November 4 *Times-Democrat* said of the situation

The Lafourche Parish courthouse in Thibodaux was utilized by Judge Taylor Beattie as his headquarters during the 1887 sugar strike. A Gatling gun was placed on the steps when Louisiana state militia forces were in town to aid planters in breaking the strike. *James Loiselle.*

in Terrebonne. "Quite a number of mills who have been idle for over a week were seen running this morning, the laborers on each place agreeing to work for the wages universally established by the planters."

The peace so described was, however, limited to Terrebonne. Workers from there who had struck were making their way to Thibodaux, increasing the throng of "idle" black workers in the town. Pierce, riding a horse borrowed from a planter, made his way with the Lafourche guards, his own men and other authorities from plantation to plantation in and around Thibodaux, backing up the eviction orders written by Beattie, enforced on jeering, taunting workers who believed, according to some accounts, that they might actually prevail.[91]

Conditions were also deteriorating in St. Mary Parish, where evictions were ordered. Strikers in the town of Pattersonville made threats to kill strikebreakers and to burn sugar houses. Twelve arrests were made for trespass on one plantation, and Judge R.D. Gill ordered that in addition to appearance bonds of $50, each would be required to pay a $250 peace bond before being released. A detachment of local militia from the parish kept guard overnight at the courthouse, over fears that attempts would be made to break them out. Tensions soared, and on H.N. Pharr's Fairview Plantation,

four white workers were shot at. A mounted posse was formed and searched for the gunmen, to no avail. But at daybreak, two companies of artillery moved in, as the sheriff and his posse "attempted to make necessary arrests of the ring leaders of the turbulent negro strikers when a collision ensued, in which four of the negroes were killed."

A more detailed version appears in the *Times-Democrat* of New Orleans, which states that the Attakapas Rangers, one of the state militia units assigned to St. Mary, approached a pair of cottages near the entrance to the town. The troops were accompanied by a civilian posse appointed by the sheriff. One was occupied by a white man named Hibbert and the other by "colored people."

"Here, as the troops approached, they found a crowd of fifty to one hundred excited negroes assembled. This crowd was ordered to disperse at once, which some proceeded to do, while others stood fast and assumed a defiant attitude," the report states. "One negro of notorious character threw his hand behind him as if to draw a pistol, then in a minute the whole affair was over. A regular fusillade was opened upon the negroes by the posse and four men were shot dead where they stood."

The report estimates that between thirty to one hundred shots were fired over an order from the Rangers' commander to refrain, given "with some difficulty."

The dead were two brothers, Wash and Dolph Anderson; Lewis Cooper, their brother-in-law; and a "negro saloon keeper" named Robert Wren. Wren, the report states, had, a year before the shooting, killed a man at the very spot where he fell.

St. Mary Parish planter and politician Don Caffery, who was present at the shooting as a temporary deputy, said, "I saw no negroes fire."

He had been told that some of the four dead men had arms but saw no proof of this.

"Some of our men fired in the air," Caffery said, estimating the number of rounds fired at seventy-five to one hundred. "Everybody thought the negroes were attacking the posse when firing was heard in front. I am informed that this firing was really done by some of the white citizens, who were presumably drunk at the time."

Already stymied from escape or other response to the show of force because troops had control of the railroads, St. Mary Parish strikers had little choice at that point but to return to work, and many did just that.[92]

In Lafourche and Terrebonne, some growers did give in to the strikers' demands. These planters were those with the most to lose because their

Sugar barns like this were used to store cane ready for processing. *New York Public Library.*

farms were small. With shrinking credit options due to the horrendous crop of the prior year and shrinking provisions, acceding would appear the better part of valor.

Mary Louise Williams Pugh, whose husband, Richard, had died in 1885, communicated by letter with relatives about the strike. She appeared to have been living in Thibodaux at the time, closer to the center of town than the plantation she and her husband had maintained until his death in 1885. The Pughs did not own that plantation, which they ran for Mary's sister-in-law Fannie, wife of Judge Taylor Beattie. Modern descendants are not certain where in Thibodaux Mary was living when she wrote to her son Chuckie, who was away at school, that there was "a good deal of excitement here for the last few days owning to the fact that the negroes have all struck for higher wages."

"The Planters all had a meeting and agreed that they would not pay a dollar twenty-five cents a day and sixty cents a watch and in consequence all the negroes have struck except those on Mrs. Andry, Mr. Whitehead's and the Hoods'," her letter states. "These places had already promised to give these wages, so they are sticking to their bargain. All the negroes are coming

into town and the vacant houses are fast filling up. A good deal of trouble was expected in having to drive the struck negroes, you see that if we had not troops here there would be very strong changes of trouble here."[93]

The upper Lafourche Parish planters with large holdings or multiple farms appeared to have had the better ability to hold out against the strike, confident that military might would prevail. These more prominent planters also had other reasons to stand firm, most of them having been officers in the Confederate army and highly regarded by their neighbors and friends. Having lived through their inglorious returns from war, the humiliation of Reconstruction and the indignities of true democracy, which placed them on an equal playing field with their former inferiors when their votes could not be bought or cajoled, the strike was clearly a challenge to all they held dear. It was at their behest that the state's troops had come, to enforce their edicts and reject the insolence fed by "anarchists" and "Communists," as they branded strike leaders, withholding their greatest disdain for the labor activists who were of their own race. In their journals and in letters to newspapers, some of the planters wrote words almost conciliatory and benevolent when referring to their black workforce. They regarded them as having been misled, duped and fooled.

Many of the strikers, however, had histories and memories of their own, no less traumatic or less deeply ingrained. Emancipation had occurred only twenty-two years before, and for many of the workers on Louisiana's sugar plantations, the sting of slavery's lash, both physical and emotional, was more than mere memory. That conditions of living in the new postwar world were barely distinguishable from those of slavery times was no doubt a frustration. What good was freedom if one was not economically free to leave the grounds of his place of birth, to make a better life for self and family?

That little had changed after emancipation is evident in one of the letters from Mary Louise Williams Pugh to Chuckie. She wrote on November 4 that she and his brother Preston were doing all the work at their home "for the man that mother hired in Tom's place got saucy and she had to whip him." This more than twenty-two years after the war.

The results of the strike in human terms were evident at every road leading to and from Thibodaux, where evicted strikers and their families camped out, transforming the outskirts of town and, eventually, streets within its limits into refugee centers.

"[The strikers] are being brought into town where they are all dumped together. Every vacant room in town tonight is filled with families of penniless and ragged negroes," a *Picayune* reporter wrote. "All day long a

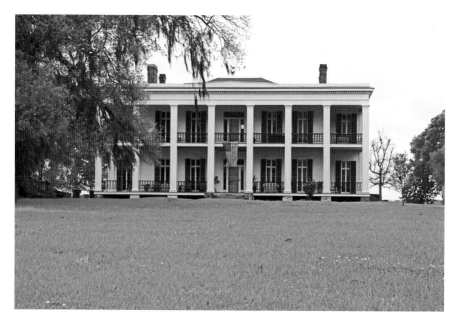

Ducros Plantation in Schriever, Louisiana. It is believed that striking sugar cane workers stole a cow from the plantation grounds. *James Loiselle.*

stream of black humanity poured in…bringing all their earthly possessions, which never amounted to more than a front yard full of babies, dogs and ragged bed-clothing. On many of the plantations old gray-headed negroes, who had been born and lived continually upon them, left today."[94]

The papers said the strike had ended, but the reference was to Terrebonne and not applicable to Lafourche. The strike, and the military intervention, was leaking out slowly to the nation at large, and some voices were raised in the national press, protesting the military's aid to the planters.

"Immediately, and without a call from the civil authorities of the parishes, Gov. McEnery ordered troops with a Gatling gun…and there men have been forced, at the point of the bayonet and the muzzle of the Gatling gun, to return to work at the wages dictated by the sugar planters, behind whom is the power of the state of Louisiana," states an editorial in the *National Republican* newspaper, a partisan but impassioned piece that criticized the relative apathy of activists in national labor circles to the troubles in the Bayou State.

> *Do the workingmen of the country understand the significance of this movement? The negroes…are practically disenfranchised. Their votes are*

of no value, and for that reason they can be forced to work at starvation wages, in the richest spot of land under the American flag. The servile labor of the south is servile and controlled by bayonets and Gatling guns because the white voters of the north, the men who labor with their hands, do not protect their ignorant fellow workingmen in the rights which the constitution guarantees them, and allows Democrats to control the country.[95]

A writer to the *Chicago Times*, W.B. Merchant, complained that Louisiana planters benefitting from the national tariff on imported sugar had little moral ground to stand on in refusing demands by workers to halt the use of plantation scrip.

"The plain facts are that the hands on our sugar plantations are not much, if any, better paid and cared for than the pauper laborers of Europe," Merchant's statement reads.

First-class laborers on sugar plantations are paid from January to grinding season, about the first of November at the rate of sixty-five cents per day, subject to deductions for all days or parts of days lost for any cause. They are furnished a cabin or a room twelve by fifteen, in which themselves and their families may reside. Out of these wages the laborer has to feed and clothe himself and family…After all deductions for lost time are made the average laborer makes about twenty days per month, provided he does not fall sick; He therefore receives in pasteboard tickets an average of $13 per month. These tickets are not transferable and can only be negotiated at the plantation store, where they are exchanged for meat, bread, etc. at the prices fixed by the storekeeper, who generally represents the planter. These prices are generally fixed at about 100 percent over the wholesale cost of the goods, therefore the planter get back through his plantation store in profits on his goods about one-half of the wages which he pays the laborer, which makes the actual wages paid by the planter about $6.50 per month.

Merchant determined that the demand of $1.25 per day and $0.60 for night watch were far from unreasonable, particularly since the demand included elimination of scrip.

Yet the planters have organized themselves, advised and caused the governor to order out the state troops, and refused to pay the wages and demands by the laborers, several of whom were shot and killed at Pattersonville last Saturday. The outlook at present is gloomy for the hundreds of laborers who

have been driven from their cabins and are now without food or shelter other than such as has been given them in the towns by those of their own color, who are poorly able to provide for themselves.

In and around Thibodaux, General Pierce halted his mount from time to time and spoke with striking workers not yet evicted from their housing.

"They seemed determined, said they would not go to work and that they would be provided for. They had been told by their advisers that the authorities could not evict them, that the planters had no right to move them from their homes and that in a very few days they would all be at work at their prices, and the planters would be compelled to employ them," Pierce reported.[96]

The general's rounds were interrupted when word came of violence on one of the Lockport plantations. A large crowd, he was told, had gathered at Richard Foret's place. The beleaguered planter had been shot.

8

A DEADLY BALL

General Pierce thought it best to learn what had occurred near Lockport firsthand and, accompanied by a Lafourche deputy named Richland Frost, traveled the twenty-three miles not on his mount but in a buggy. The trip had a twofold purpose: to ascertain facts concerning the Foret shooting and also to drop off ammunition and blankets to the detachment of militia at Lockport.

Foret had indeed been wounded and was expected to recover.

The circumstances of the incident are yet muddled, with minimal documentation. What records exist indicate that Moses Pugh, a black labor activist, shot Foret in self-defense. At a later trial, the jury found Pugh guilty of attempted murder but recommended mercy from the court, and Pugh was sentenced to only one year in prison.

"Mr. Foret was not badly hurt, one ball grazing his stomach, another making a flesh wound in the leg," the court papers state.

Pierce wrote that he encountered "a frightened group of negroes" along the roadside near Foret.

"They were afraid the troops would kill them," Pierce wrote in his report to Beauregard. "I conversed with them and told them they would not be molested if they behaved and did not interfere with with men who desired to work. A few hands were still working at Foret's place."

The militia stationed at Lockport had come to assist Sheriff Thibodaux, whose attempt to arrest Moses Pugh was met with resistance by strikers.

When the militiamen first approached, Pierce reported, "the negroes hooted and used violent language, the women waving their skirts on poles,

and jeering," basing the entry on his debriefing of Captain Taylor, the militia commander stationed at Lockport. "The negro [Pugh] surrendered to the troops in an instant, the large crowd surrounding him dispersing immediately on the order of Capt. Taylor," Pierce wrote.

Pierce credited Taylor with keeping order sans further bloodshed by ordering his company to advance toward the plantation quarters "at the double quick," firing shots into the air and mounting a feigned bayonet charge.

More military muscle, meanwhile, was requested for Houma, where strikers were balking at the numbers of replacements being brought onto the plantations. Pierce was stretching his resources thin. At Acadia Plantation in Thibodaux, about thirty workers were scheduled to arrive on a train from New Orleans by way of Schriever. Pierce ordered Benham's battery to accompany the replacements, a task that was performed without incident.

In Houma, meanwhile, H.C. Minor—in a near-replay of what had been experienced in 1874—reported to authorities that a group of strikers was headed for his place.

Replacement workers for Minor's plantation were brought to the train station in Schriever, where they were met by an angry mob of strikers. Pierce had ordered the Napoleon cannon from Thibodaux to be placed on a rail car, and troops, with bayonets at the ready, saw to it that all the mob could do was jeer. Evictions were carried out on more Terrebonne plantations, with some newly homeless workers and their families headed to Houma and others embarking on the long trek north to Thibodaux, swelling the already untenable number of strikers camped along the roads and bayou sides. Some, as messages to newspapers indicated, received sustenance from churches, aid societies and households in the "back of town" section of Thibodaux, almost exclusively occupied by black families. The origin of some of the food was in question. At Ducros Plantation, alongside Bayou Terrebonne in Schriever, nearly to Thibodaux, there were complaints that strikers had stolen several head of cattle, according to its current owner, Richard Bourgeois. The suggestions he found in old records when he purchased the property were that the ill-fated bovines were used to aid the strike effort, along with purloined hogs and chickens.

Great umbrage was taken by planters and officials in Thibodaux, meanwhile, of a manifesto drafted in New Orleans by the Knights of Labor, criticizing the use of state militia to do the bidding of the planters.

The document outlined the history of the strike to that point, noting that the KOL's initial demands on planters "couched in respectful and courteous language, was entirely ignored by said planters and treated with contempt."

The refusal of planters to recognize the KOL as the representative of the workers and creation of a blacklist to keep striking workers from employment elsewhere was criticized, as was the assistance given by McEnery.

"Without color of authority or necessity the Chief Executive of the state of Louisiana ordered out state troops to enforce the aggressive and arbitrary will of said planters," the manifesto states, noting the arrests of laborers and the killings in St. Mary.

> We condemn and censure the actions of the chief executive of the state, Samuel D. McEnery, in ordering out the state troops to be uncalled for, and without authority or precedent, and that we admonish the governor of the state of Louisiana that he shall not over-ride the rights of her citizens to peaceably assemble and ask for a fair compensation for their honest labor… he must respect the constitution and laws of this state and cease the offensive display or use of military force during a conversation between employer and employee, when no attempt is made or intended to violate law and the peace and dignity of the state.

From information in their possession, the KOL leadership said, the killings in St. Mary were assassinations, and they demanded a formal investigation of the deaths. The manifesto then pledged an effort to lobby congressmen throughout the nation to repeal the sugar tariff, promising that nationwide, "millions of workingmen" would push the issue with their elected representatives.[97]

The manifesto was widely circulated and, as could be expected, toughened the position of the planters, who continued to refuse any negotiation in Lafourche. It was published at a time when there was clearly no desire by Pierce—or other state militia officials—to keep troops in the region. There were no guarantees in 1887 that state militiamen's day jobs would be protected, and some of the troops were expressing concerns. Pierce's reports showed that, when possible, he changed out companies of troops while assigning and reassigning various units to volatile places in both Terrebonne and Lafourche. The planters were uneasy with the thought that strikers—many of whom were still congregated near plantations in various areas—might return to their farms and either harm replacement workers or encourage them to walk out. Pierce's reports indicate that the peacekeeping had achieved a level of almost choreographed monotony.

"I told them that they must soon dispense with the troops," Pierce sated in his report to Beauregard, referring to a conference with some Terrebonne

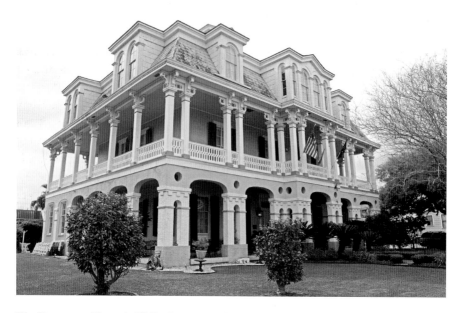

The Dansereau House in Thibodaux, now a bed-and-breakfast, was home to one of the members of the Peace and Order Committee in Thibodaux that enforced martial law in the days leading up to the Thibodaux Massacre. *James Loiselle.*

planters. The general chafed at a request that his troops might help supervise workers in the fields who were not producing or were discussing further labor organization with their fellows. The soldiers, Pierce said, would not be used to supervise cane cutters.

A contingent of militia from Caddo Parish—a region that, before 1887 and after, saw perhaps more lynching than anywhere else in the state—had been dispatched to the area, and its members were assigned to keep order on the lower end of Bayou Lafourche near Lockport. The so-called Shreveport guerrillas remained there as other companies were phased out, not replaced by order of either Pierce or Beauregard, his superior. Despite rumors of threatened violence that prevailed through his entire stay in Thibodaux, Pierce had seen few indications of it other than the scattered incidents he had directly dealt with, such as the shooting of Foret.

By the second week in November, the military's role was officially winding down. While the strike was mostly quelled in Terrebonne and St. Mary, the epicenter of the labor movement was still present in Thibodaux. Planters there had not, as had those in Terrebonne, made arrangements for replacements, for the most part, seemingly convinced that they could force their workers back into the fields or that the strike would starve them into working.

The diminishing number of troops emboldened strikers or perhaps made them puff up in a defensive posture. Their words and taunts caused alarm among the white townspeople. Black men walking the streets began carrying arms, ostensibly for protection. Acts of random violence included assaults on replacement workers or seasoned hands who had refused to strike. A sugar boiler named Boblis was fired on by "persons unknown" but not wounded. The overseer at Rienzi Plantation had been shot in the face, though not severely injured. Four white workers on the Ridgefield Plantation were shot at, though not hit. In the actual homes of Thibodaux's sugar elite, domestic workers—primarily women—muttered threats, causing fear among the wives of planters and politicians. There were rumors of murders that never occurred. The telephone was in limited service at select places in the nation by 1887, though its development was in its earliest stages. Nonetheless, Thibodaux was experiencing its own deadly game of "telephone," such as children play in school, passing messages from person to person with continued distortions and embellishments.

When Pierce made to exit with the last of his troops, Beattie begged him to leave the Shreveport guerrillas. The townspeople needed to be protected, Beattie said, while preparing for their own defense. By Friday, November 18, most of the militia—with the exception of the Shreveport detachment—had gone. That night, Judge Beattie and four of his followers barged into the Knights of Labor headquarters on St. Charles Street.

"The community must begin to look to their lives and property and protect themselves," Beattie told the union leadership, warning them that if the nighttime gunfire persisted, it would be met with force.[98]

On Saturday night, November 19, Pierce bid farewells to his hosts, and the next morning, well before dawn, he rode to Schriever, boarding a train that took him to New Orleans. He would never visit the sugar region again.

The New Orleans newspapers continued reporting the escalating tensions, nonstop. One news report stated:

> *The town is full of idle negroes who each day become more and more audacious. The negroes who had left the plantations and taken refuge in the town of Thibodaux were being put up night and day to do acts of violence…a person could not go out into the streets without seeing congregations of negroes that wrought no good to the peace and order of the town. Some of the negroes boasted openly that if a fight was brought about they were fully prepared for it.*

A residence that was once a general store on Narrow Street in Thibodaux, in the neighborhood where the Thibodaux Massacre took place. *James Loiselle.*

Labor organizers continued preaching to workers that they could prevail in a prolonged standoff against the planters. The presence of dispossessed strikers no doubt appeared threatening to the whites, particularly those of the upper classes, the Lafourche planter elite. Written evidence suggests that what had begun as a labor movement was being seen—at least by planters and local government officials—as a burgeoning race war. The weekly *Thibodaux Sentinel* ran on its pages an account of the audacious nature of Benjamin Lewis's black militia from nearly a decade before, as if it were new information rather than a rerun of ancient news. The reprint was picked up by the *Picayune* in New Orleans and other papers.

A keen observer and follower of the events was Mary Pugh, who had since the war's end operated Dixie Plantation in Thibodaux—which was actually owned by Fannie Beattie, Judge Beattie's wife and also Mary's sister-in-law. Richard Pugh, her husband, died in 1885, and it is possible that after that time, she was living with friends or relatives in town. This is suggested because her letters to loved ones that include references to the strike are extremely detailed and could not have been garnered from the porches of the plantations with which she was associated.

Correspondence to her son Chuckie describes aspects of the strike consistent with press accounts of the time.

"All last week the negroes became more and more violent in their manner and talk & openly bragged about how those at work were being shot at every night & said the Planters would be obliged to give in," the letter states.

The St. Joseph Lodge of Free and Accepted Masons in Thibodaux was founded in 1884. One of its members, Junius Bailey, was a leader of the 1887 sugar strike. *James Loiselle.*

On Sunday, November 20, Pugh attended St. John's Episcopal Church with her son Allen and another family member. The service was sparsely peopled, with only ten congregants in the pews. The minister, Pugh related, expressed hope that the upcoming Thanksgiving Day service would go on as scheduled. As she walked out of the church, she saw that "over one hundred negroes were congregated just opposite & an another such group just across the canal where some negro was making them a speech to 'burn the town.'"[99]

A barrel maker identified in the newspapers as Rhody DeZauche had indeed given a speech that Sunday on the bayou side that was determined incendiary by the authorities. DeZauche was arrested, jailed and charged with attempted murder. His words, the prosecutor said, posed a danger to life. After her visit to the church, Mary Pugh was horrified by other indications of burgeoning black "insolence."

"I met negro men singly or two or three together with guns on their shoulders going down town and negro women telling them to 'fight, yes, we'll be there.' You know what big mouths these Thib. negro women have—I wish they all had been shot off. They are at the bottom of more than half the devilment. Well I got home as fast as I could," Mary Pugh wrote.[100]

Several newspaper accounts noted the vociferous inclinations among black women:

> *The negro women of the town have been making threats to the effect that, if the white men resorted to arms they would burn the town and* [end] *the lives of the white women and children with their cane knives. It is no longer a question of capital against labor, but one of law-abiding citizens against*

assassins…Things changed for the worse, and citizens were afraid to go out upon the public highway for fear of being shot from ambush.

Unsubstantiated reports flew through Thibodaux streets that a black uprising was imminent. A cache of weapons, someone said, was being kept at locations on St. Charles Street, and an "alarm of riot" was sounded. One hundred armed white men converged on the back-of-town black neighborhood.

"The report was circulated to the effect that two hundred armed colored men were massed for the purposes of mischief in the rear of town," is how the *Thibodaux Sentinel* framed the story. "The sheriff with an armed posse started out at once for the scene of the alleged trouble. But the matter turned out fortunately to be a false alarm."

That Sunday night, as the last of the Shreveport guard prepared to leave, a mass meeting was held in Thibodaux's town hall, chaired by Judge Beattie and attended by about three hundred "of the most prominent residents." Silas Grisamore, who had chronicled the hardships of Camp Moore, initially presided, then asked Lieutenant Governor Knobloch to take over. A *Picayune* reporter was present and later wrote that those assembled represented "all trades and professions."

"For the past four days, would-be assassins were prowling about at night shooting into sugar houses, on one occasion shooting at a horseman on the public highway," the *Picayune*'s report states. "Several persons have already been wounded by these night prowlers. One man died from the effects of the wounds received, and another lost an eye. Such lawless acts must be put down at all hazards."

The bilingual crowd was agitated, and if the showing in the black quarters of town earlier on that Sunday was any indication, townspeople previously uninvolved with the matters between planters and their workers were ready to take a stand.

A resolution was hammered out, presented by the boiler maker Ozeme Naquin, which stated that threats of violence received from the strikers and their sympathizers were "a disgrace to the parish and a reproach upon its good name for law and order.

"This state of disorder shall and must cease," the resolution continues. "We all, regardless of calling, avocation or pursuit, do now pledge ourselves and each other to use every means in our power to bring the guilty parties, and those who may have advised such lawlessness, to a speedy detection and punishment."

The "guilt" referred to involved a wide range of offenses. The strike itself was regarded as lawless, as was the vagrancy of the evicted. Nobody knew who had been doing the random shooting at sugar houses and replacement workers. But it was certainly a major concern.

The resolution offered a reward of $250 "for the detection of parties guilty of those offenses."

A core Committee on Peace and Order was selected. Its members were Judge Beattie, Emile Morvant, Major Lagarde, Andrew Price, L.A. Trosclair, Dr. (Hercule) Dansereau, Dr. J.H. Fleetwood, Louis Julian, Ozeme Naquin, Ellis Braud, Lawrence Keefe, E.G. Curtis, John Seely. H.W. Tabor, Alceste Bourgeois, Taylor Legarde, A. Molaison, L.D. Moore and Thomas Beary.

Sheriff Thibodaux offered to swear in thirty deputies, and patrols were promised to ride "day and night" to search out the guilty.[101]

To state that the most prominent people in town were at the meeting was no exaggeration. In addition to Knobloch, Beattie and Grisamore, the committee appointees were a who's who of local commerce. Morvant, Lagarde and Price were owners of successful plantations. Dr. Dansereau,

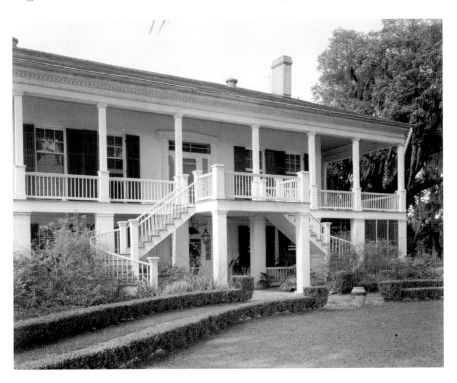

Rienzi Plantation, north of Thibodaux. *James Loiselle.*

a respected physician, was owner of one of the town's finest homes, which stands to this day. Keefe was the owner and operator of Thibodaux's celebrated foundry; Ozeme Naquin would move on from boilers to being a director of one of the town's most successful banks. Andrew Price was an attorney and planter who would go on to be a congressman.

One of the committee's first acts was to shut down the town entirely, requiring passes for people to enter or leave, amounting to martial law. Another was to seek out George and Henry Cox and jail them for inciting violence.

Letters from Mary Pugh and others express approval and support for the turn the town was taking. With the militia gone, Thibodaux would have to protect itself from the specter of marauding blacks. One of Mary Pugh's letters reads almost as a portent: "They tried to [sic] hard to keep the peace they knew if things was once begun it would have to be well done, to end the trouble. I marveled at their patience."[102]

A young man of Pugh's household named Jamie—descendants say they don't know who he might have been—joined a local militia company headed by Lewis Guion, a local Civil War hero and former member of the Knights of the White Camellia. The cordoning of Thibodaux was done to contain blacks who were within and to prevent the entry of other people sympathetic to the strike. Some historians maintain that the order was perceived as a threat by strikers, who feared they would be penned in and attacked. Volunteer sentries were set up on the roads leading into town, their purpose to challenge travelers going in or out and to keep watch for the protection of life and property.[103]

Pugh wrote that "the negroes became insolent and sneered at the soldiers and the citizens on the streets."

"They proclaimed publicly that the white people were afraid to fire upon them and that they were prepared," states a newspaper account. Whether they really were prepared—and the history as it developed shows they were not—the white citizens of Thibodaux were. Mary Pugh found her son Peter molding bullets at her home, and when she inquired as to why, he simply told her, "We might need them."[104]

On Monday, November 21, "over two hundred planters & white men had met in Fireman's Hall all armed, for they expected trouble surely that day," according to Pugh, who was under the impression that, despite the rancor, there had occurred some behind-the-scenes negotiation on the wage increase strikers sought.

A notice, meanwhile, was sent out stating that the town would be patrolled, noting that "all are so wrought up at this moment the most trifling incident will bring on a terrible massacre."

Armed vigilantes on horseback patrolled day and night, looking for anything that smacked of continued support for the strike and the potential for harm.

Mary Pugh wrote that "everyone was on the watch least [*sic*] they would attempt some violence…White men were armed & guarded day & night—of every street & inlet to the town."

The patrollers—blacks called them "regulators"—made their purpose clear, sometimes with violence.

Peace and order enforcers, on Monday, stormed the St. Mary Street barroom of Henry Franklin, a black parish councilman and early supporter of the strike and a member of the Knights of Labor local committee that drafted the initial demand to the planters. Gunshots were fired into the saloon, and two black men were wounded. One of the wounded, William Watson, a twenty-three-year-old black laborer, ran out into the street but collapsed and died. The other, Morris Page, made his way home and survived. The assailants were not known to Franklin or other witnesses.

Despite the official sealing of the town, white men converged on Thibodaux from other parts of Lafourche to assist as rumors spread through the countryside. A "committee" of men from Terrebonne Parish made their way to Thibodaux as well.[105]

A solitary laborer walks a Louisiana cane field. *New York Public Library.*

Despite manpower shortages, local plantations tried to work their crops. A frost was feared and could spell ruin. At Captain Whitehead's Abbey Plantation, where cane was being cooked, it was essential to keep engineers and mechanics at the ready to deal with any potential problem. Jack Conrad had gone to work every day, traveling the four miles between his rental house and the farm each way. On Tuesday, he was not feeling well.

"I did not go on the strike," Jack later said. "None of the mechanics went on the strike. About three weeks after the laborers had quit work, I was taken sick. I told Mr. Whitehead that I would like to go home, and he let me go home."

"Home" for Jack would have been a small to medium-sized, shotgun-style house or cottage, with small yards in back and front. Examination of property records show that it was likely a house on St. Michael, a short, sparsely traveled street in a neighborhood that was integrated but mostly occupied by black workers from various area plantations or clerks and other lower-paid people. His wife, Mary, would have greeted him. Clarisse or Clarissa, the eldest child, no longer lived with Mary and Jack but with her husband, Jesse Jackson, a laborer. But the records indicate that she lived close by. Grant was nineteen years old and still living with his parents, along with his younger brother, a laborer named Manfred, who would have been fifteen years old.[106]

Jack had to have noticed the town's lockdown status and would have had to present a pass from Whitehead to get back into Thibodaux when he left work in order to get past the pickets. The passing of the regulators on their horses would not have been a comforting sight, but Jack had nothing to fear since he had remained working. Armed white men, as well as the recently departed militias, had become a common sight.

While Jack Conrad slept, after darkness fell, the night guards took their places at various points. Mary Pugh's son Peter was en route back home from his assigned volunteer post outside town, driven by his brother in a carriage. On the southeast corner of town, not too far from where Jack lived, Henry Molaison and John Gorman began their night watch.

The location Molaison and Gorman manned was critical, near the point where St. Charles Street branches off of the main thoroughfare of the town, where ran the canal linking the bayou to Houma. It was also a gateway to the black section of Thibodaux, where the committee suspected strikers and their supporters were plotting "mischief" and "assassination."

Gorman was a boiler maker by trade, an Irishman with bushy eyebrows who had sold Mary Pugh a horse at one point in time. Molaison was a

clerk in his own father's feed store. The night was a chilly one, and the pair stoked a bonfire to keep warm. At around 5:00 a.m. on Wednesday, November 23, Molaison and Gorman were having a "friendly discussion" with two other watchmen named Anslett and Gruneberg, about 250 yards from the still-burning bonfire, when a shot rang out.

"Gorman rolled over into the ditch nearby," Molaison said. "I thought it was a pistol shot."

Gorman was accompanied to his home by two of the civilian guard, and five minutes later, Molaison asked Anslett and Gruneberg to take his own place so he could go check on his friend.

"I had gone about 200 yards from Anslett when I was shot down," Molaison said. A single bullet had entered the young feed clerk's face just below the eye and then dropped out of his mouth.[107]

"The news spread like wildfire and everyone was at arms," wrote Anna "Nanny" Gay Price, the mistress of Acadia Plantation and wife of Andrew Price, in a letter describing the events in Thibodaux once the sun came up.[108]

Mary Pugh's segue into her account of what followed was chilling in its near-poetic tone: "And this opened the Ball."[109]

9
MASSACRE

The hooves of horses on hard gallops raised towers of dust on Thibodaux's wide boulevards and narrow side streets as armed white men responded to the cries of alarm. Whoever fired the shots that felled Molaison and Gorman could not to be found, but the black neighborhood in Thibodaux offered plenty of targets for vigilantes consumed by vengeance, fear or combinations of both.

While the predawn volleys from the cornfield didn't kill the sentries, they succeeded in killing a fragile peace, with Clay Knobloch's Lafourche militia and hundreds of volunteers rushing to the town's black quarters. There is no documented attempt of those involved to follow the rule of law, or any hint of blacks taking up arms, or shots being exchanged once the rampage began. White guards and citizens opened fire on blacks, storming homes and rooming houses without authority or warrant. One account describes a charge on a brick St. Charles Street building, believed to have housed women, and the children of striking parents.

"There were several companies of white men and they went around night and day shooting colored men who took part in the strike," said the Reverend T. Jefferson Rhodes of Thibodaux's Moses Baptist Church, his words preserved on a handwritten affidavit on file at the U.S. National Archives, uncovered in 2016.[110]

"I was an eyewitness to the shooting of my father by the regulators," said Clarisse Conrad, placing the number of the mob at fifty or sixty.

He and my brother Grant and my Uncle Marcelin Welden and my mother and myself were all at home. The white men came to our house and they saw my mother in the back yard emptying a tub, and they told her if they had any men in the house to tell them to come out damned quick. Before mother could tell them to come out my father and brother and my uncle, being attracted by the noise, stepped out.[111]

Jack Conrad himself said he was sleeping when the violence came to his house and that the commotion woke him.

"I think there were about 50 or 60 men in the crowd, which was comprised entirely of white citizens who lived in and around Thibodaux," Jack said. "When I opened the door one of the mob said 'crack down on him' and at that they went to shooting."[112]

Jack, his son Grant and his brother-in-law Marcelin were told to line up, and they began to run.

"I heard my uncle tell them he wasn't in it," Clarisse Conrad said of Marcelin.

And they said "get back you son-of-a-bitch" and shot him down and killed him. My brother was back of the house and got behind a barrel and the white men got behind the house and shot him dead. My father crawled under the house and they shot him under the house. He fell on his face when they shot him. After he fell on his face I heard them say "he is dead now" and "let us go." My father was shot in both arms and was also shot in the breast. His collar bone was badly broken and some of the little bones came out. I know that my father was unarmed when the white men came and called him out.[113]

Jack Conrad named Tom Kemp and John Golliar, as well as Captain Whitehead, his employer, as being among the men who shot him. Whitehead, he said, did not appear to recognize him.

The shooting continued in Thibodaux as the morning wore on; more than one witness said in sworn statements that the gunfire persisted for two and a half hours. Other accounts said the shooting was still going on after nightfall. All indications are that the events occurred in different areas, with witnesses in one small neighborhood not necessarily knowing what was going on in the next.

Mary Pugh's accounts of the violence place her not far from the present intersection of Canal Boulevard and Jackson Street, most likely somewhere between that intersection and the Frost Lumber Yard, where at that time

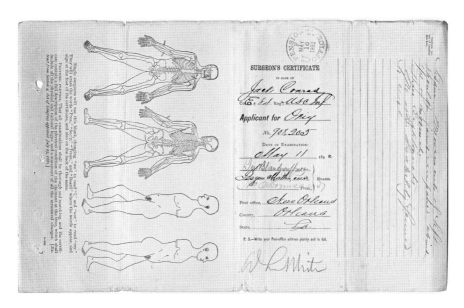

Medical records depicting Jack Conrad's gunshot wound injuries suffered during the Thibodaux Massacre. *National Archives, Jack Conrad Pension File.*

the tracks of Morgan's Railroad passed on their way to the bayou. As the morning wore on, she saw one of the strike leaders—the white Englishman J.H. Foote—being led at gunpoint by whites, along with a crowd of black men, toward the courthouse.

"They began then hunting after the leaders and everyone that was found of any suspicious character was shot," Mary Pugh wrote. "The rifles on St. Charles Street sounded like a battle."

Her son Peter had joined one of the groups.

"He was awfully excited," she wrote. "[He] bolted right in the midst of it when he heard the fighting."

Andrew Price, a captain of one of the militia companies and owner of Acadia Plantation, sent the young man home "and then sent me word to keep him here." The various companies, Pugh wrote, "went all over town searching for those wanted, would march them out to the commons and shoot them down." So seriously did Mrs. Pugh take what she was seeing that she hid a black man she favored—possibly a house servant—in the kitchen to make sure he was not accosted by the mob. She also described how Price's company found an alleged strike leader in the loft of a house near the canal and flushed him out to join the other prisoners they held. "They brought them by one side gate, I thought they were taking them to jail.

Instead they walked with one over to the lumber yard where they told him to run for his life [and] gave the order to fire. All raised their rifles and shot him dead. This is the worst fight I saw but I tell you we have had a terrible three days & Wednesday excelled anything I ever saw even during the war."[114]

At a plantation about fifteen miles south of town, Covington Hall was told late in the day by his uncle George Jones that "a terrible riot has broken out in Thibodaux. The shooting began about 6 o'clock and is still going on." According to the accounts Hall later gathered, the fate of the man marched out of the house by Andrew Price and his posse was not unique.[115]

"The cry went forth to arms, to arms, the negroes are killing the whites…[and the whites] came forth and fired volley after volley, in to the churches, the houses, wherever a negro could be found," a report from the *New Orleans Weekly Pelican* states, citing an eyewitness account that "no less than thirty-five negroes were killed outright. Lame men and blind women shot; children and hoary-headed grandsires ruthlessly swept down. The negroes offered no resistance; they could not, as the killing was unexpected. Those of them not killed took to the woods."[116]

As the sun rose higher over blood-soaked streets, some blacks were touched by luck.

Joseph Reed, the black farmer from north of Thibodaux who remembered the terror of a decade before, had no idea what was occurring as he guided his horse-drawn wagon on a routine trip for supplies with one of his sons on board. A shortcut took him on a path through Abbey Plantation. But the errand was cut short.

"He was stopped by the Abbey Plantation overseer, a white man, who told him not to go to town," another of Joseph's sons, the late Ulysses Reed, recalled in a 2001 interview. "He was a good white man. He told my father and my brother they are shooting people there, to turn around."

Joseph Reed did as was suggested, not learning of what he avoided until a few days later.[117]

The Abbey overseer may have had some direct knowledge of the intentions that day. The plantation's owner, N.W. Whitehead, was identified by Jack Conrad as one of the mob that shot him and killed his son and his brother-in-law.

Another lucky African American was Thomas Cunio, a storekeeper in Thibodaux living on the far eastern end, who escaped with a gunshot wound that went clear through his left hand. At 7:00 a.m., he was getting out of bed when white men called out to him from the gate of his home. The mob began searching his closed store for guns, ammunition and fugitives,

they said, but found nothing. They ordered him to get behind his counter and then fired. In addition to being shot through the hand, Cunio suffered grazing of the feet.[118]

That black people were pursued into the woods and swamps was well verified by parties with little sympathy for the strikers or their cause, and by some accounts the shooting went on until noon. Eight bodies were initially recovered, and a ninth later on, but more were to come.

Estimates of the death toll have numbered from a pitifully deficient six to the hundreds, although an examination of most historical accounts would indicate a number between thirty and sixty, with many more wounded. Jack Conrad and Reverend T. Jefferson Rhodes both said they were told of sixty dead. Mary Pugh herself estimated the number at around fifty, though her perspective—like those of others who witnessed aspects of the violence—would have been restricted. An account in the *Lafourche Star*, a short-lived Thibodaux newspaper, describes "negroes jumping over fences and making for the swamps at double quick time."

"We'll bet five cents that our people never before saw so large a black-burying," the article states.[119]

The only verifiable accounting of the dead appears in an inquest report filed by the parish coroner, which identifies eight victims, including Grant Conrad and Marcelin Welden. The inquest contains the names of the victims and no other information about them. The identities have since been cross-checked with census records and other documents, as well as, when possible, interviews with descendants. The others included Felix Pierre, a thirty-year-old laborer and husband of a woman named Carolyn. They had lived on President Street. Louisa, Rachel, Felix Jr. and Alex were their children. Another President Street victim was Archie Jones, a seventy-year-old man who had lived there with his wife, Kitty. Mahala Washington, a seventy-eight-year-old woman, was killed. She also had lived back-of-town with her husband, George. Willis Wilson was a thirty-five-year-old laborer, married to a woman named Josephine. Their children were eighteen-year-old Allen, fourteen-year-old Roberta, fourteen-year-old Harrison and ten-year-old Pinksey.

Frank Patterson and Riley Anderson are the others whose names were included, but information on their families could not be found. The inquest was held the same day as the deaths, with the jurors attesting that these dead were killed "by persons unknown." Their number included men who had led the mass meeting at which the Peace and Order Committee was born. First on the list of inquest jurors was the retailer and Civil War scribe Silas

The state historical marker at Rienzi Plantation, outside Thibodaux, where three bodies of massacre victims were found. *James Loiselle.*

Raymond Stafford Post 513 American Legion Hall on Narrow Street in Thibodaux. The grounds that now belong to the post are believed to contain an unmarked grave of people killed during the 1887 massacre. *James Loiselle.*

T. Grisamore, who had called the mass meeting to order. Due to his role as a correspondent for New Orleans newspapers, as well as the *Thibodaux Sentinel*, it is possible—even likely—that some of the accounts that appeared in print flowed from his hand.[120]

Bodies, according to the papers, appeared for weeks to come, including three on Richard Allen's Rienzi Plantation. A check of black cemeteries that were in operation at the time reveals no clues about the resting places of the dead, known or unknown by name. But the American Legion's Raymond Stafford 513 Post Hall on the Thibodaux back-of-town's Narrow Street, close to where Jack Conrad lived with his family, has an official history noting that its site was once a city landfill. Prior to that, the land, the history states, was a dumping ground for bodies of those killed in the massacre. Local residents of the immediate area refer to the land where the Legion Hall is located as a "graveyard" but have little else to say. The location is not listed as a cemetery in any official records.[121]

If so many were killed, as various accounts state, then why would the official inquest list only eight? Any proposed answer would be purely speculative. But most of those listed on the inquest papers were people who lived in Thibodaux at some point and so would have required accounting for. Other victims may have been among the throng from other places, not locally known and thus easily disposed of and forgotten.

10
AFTERMATH

During the course of the mêlée, panic ensued among both whites and blacks, who boarded trains out of town as quickly as the cars would come. White Thibodaux residents met in New Orleans by a reporter from the *Times-Democrat* estimated the number of blacks killed at fifteen to seventeen.

"The reason for killing the negroes was because they shot at the guards, who had been watching the city, because it was threatened to burn the houses and kill the women and children," said Mrs. Edgar Rivier, whose husband was a member of the Lafourche Militia. She fled to New Orleans with her children, mother and three sisters, arriving at the Crescent City on a 5:00 p.m. train.

> *We were afraid that they were going to burn the houses and murder us when we heard the shooting. After the shooting everything was quiet and by 11 o'clock all the negroes had fled from the town. The negroes don't want peace, they want to fight and when they get into a fight they run away. All the trouble is caused by several darkies and white leaders. These leaders do no work and get up disturbances among the field hands and then leave the field hands to fight it out.*[122]

At Gretna, a Jefferson Parish town on the route from Thibodaux to New Orleans, Henry Franklin, the tavern owner whose business saw gunfire the night before the massacre, was interviewed. Franklin, a black Knights of Labor organizer who was also an elected councilman, said that to his

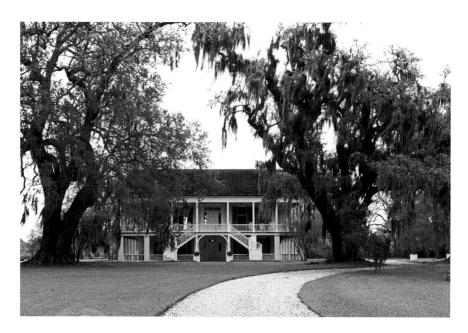

Rienzi Plantation, north of Thibodaux, where three bodies were found in the days after the massacre. *James Loiselle.*

knowledge, whoever fired on Molaison and Gorman had no connection to the strike. "As soon as this occurred the citizens of the town turned out en masse and attacked the strikers wherever they met them," a shaken Franklin said. "I don't know how many were killed but heard it estimated at fully twenty-five. The shooting was quite general…I left Thibodaux because I thought I would be safer away from there." Emmanuel Banks Christian, the black Knights of Labor organizer from Mechanicville in Terrebonne Parish, had boarded the train in Thibodaux and detrained in Gretna with another organizer, Marshall Ricar, but said nothing.[123]

W.H. Nathaniel, a black man whose cousin Willie Wilson was among the dead, said the whites had run his wife off from their home.

Back in Thibodaux, Mary Pugh wrote that she was "sick with the horror" of what had occurred but that

> *I know it had to* [be done] *else we would all have been murdered before a great while…I think this will settle the question of who is to rule the nigger or the white man for the next fifty years but it has been well done & I hope all trouble is ended. The negroes* [she had written "niggars" but then overwritten it] *seem as humble as pie today, very different from last week.*[124]

The most immediate effect of the massacre on Thibodaux was the return to work of hands who had struck or were afraid to work because of the strike.

"Mr. Price has a good force of hands at work now and if this pretty weather continues will be able to make good headway," Nanny Price wrote from Acadia Plantation in a letter to her mother dated November 29. "We only had light rains although it was very threatening for a few days."

She mentioned that a man emerged from the family's fields following the massacre, asking to be brought to the jail for protection; she described him as a "very bad negro" and strike leader. Most likely, she was referring to Sol Williams, who asked Judge Beattie to jail him. Beattie refused to do so, and Williams was sent on his way.[125]

The leading Louisiana papers left little doubt about their shared opinions that black laborers had been led astray by evildoers and that, as a result, they were left holding the bag. Black people, the newspapers opined—and in 1887, newspapers were not shy about expressing their opinions and exposing their prejudice in given situations—had brought death and injury onto themselves through boasts and threats.

The planters were painted as magnanimous and forgiving patrons who understood that the field hands were not to blame for their sins. If there was any understanding among the planters or their families that the vigilante outpouring in Thibodaux was a deadly injustice, such sentiments are not part of any existing record. Some national papers picked up the story of what occurred but provided scant details, tending to downplay the role the mob played. But not all.

The *Southwestern Christian Advocate*, an African Methodist Episcopal paper based in New Orleans, offered its own opinion, suggesting that the wounding of the pickets occurred because of "Negroes being imprisoned in town."

"White guards in the town of Thibodaux attacked the Negroes on the streets or in their houses, and murdered men, women and children to the number, it is believed, of not less than thirty-five," an article states. "There was no defense, and the negroes fled to the swamp like frightened sheep. So the strike was suppressed, we judge, [with] no white man being killed."

The suggestion that silence and suppression were appropriate under the circumstances was evident in an unsigned letter that appeared in French in the *Thibodaux Sentinel*, stating, "Better for all concerned that this page be torn out of our history, rather than try to explain."

A brief "official story" ran the next day in the *Times Democrat*, signed by Beattie and other "prominent citizens," placing the death count at six and

The Reverend Dan Nelson Taylor of Allen Chapel African Methodist Episcopal Church in Thibodaux speaks to congregants about the Thibodaux Massacre in 2015. *John DeSantis.*

giving the impression that what occurred was a locally contained skirmish after the wounding of Molaison and Gorman rather than the event now more generally understood.

After an interview with Judge Beattie, the *Times-Democrat* reported that he spoke of exasperation,

> *that he had exhausted every means within reason to bring the negro to a sense of his real condition; that he had advised him time and again to beware of and avoid those who would plunge him into difficulties with which he was wholly unable to cope; that he would afford him the largest protection with respect both to life and property; but that when the shot...was fired there was nothing further left for him to do save that of assisting the good citizens in the preservation of law and order.*

The Knights of Labor and the strikers, Beattie opined, "had the means of doing incalculable damage in the parish. ...Their attack upon the people, he said, was not only unwarranted, but premeditated and malicious, so that

The back-of-town neighborhood in Thibodaux, where much of the shooting during the Thibodaux Massacre took place. *James Loiselle.*

question of the supremacy of the whites over the blacks or vice-verse [*sic*] became the absorbing question."[126]

The more immediate question for Thibodaux was whether the quiet that prevailed the night after the violence could be sustained. State militiamen were ordered from New Orleans to Thibodaux late in the day on November 23 and arrived on Thursday, November 24. There were scattered reports of shots fired near various plantations but none sustained. In Houma, there was fear that violence by laborers would ensue. Patrols were increased there, and peace prevailed.

Henry and George Cox were released from jail in the middle of the night, their charges being mere misdemeanors. Judge Beattie said the brothers were told to flee after being given their freedom and that it appeared they did so. But throughout Thibodaux, talk traveled among whites that the two men ended up either shot or with ropes around their necks. Whatever their fates, they were never seen again.

In a December 1 letter to the *Times-Picayune*, Beattie vehemently refuted a story that said the Cox brothers had escaped from the jail.

"I released them in the presence of the sheriff, one of his chief deputies and Capt. Adams," Beattie wrote. "We escorted them to the outskirts of the

town and bade them shift for themselves. …They were released at night not from any fear of an attack on the jail but to prevent their being attacked upon their release."

Beattie then presented a justification for the mob violence, without supplying clear details.

"Whatever was done has been done was done after forbearance had utterly ceased to be a virtue, and when force was actually necessary to repel the midnight attack upon the guards placed over the town to prevent a threatened attack, and to prevent the attempted murder of peaceful citizens guarding their homes and firesides," Judge Beattie's letter states.[127] Among the curiosities of this letter is his reference to a "midnight" attack on the guards, which misstates a key fact, although trying to determine the significance of this would be an exercise in quibbling. Of greater interest for posterity are the words written after, which appear in the same letter, in which the judge emphasizes his disdain for the Knights of Labor and suggests that he is fully aware that his neighbors and constituents acted beyond the boundaries of law.

"This state of affairs was brought about by a secret, oath-bound association of ignorant and degraded barbarians, who have refused and continually refuse to obey the laws of their country by testifying as to the lawlessness prevalent, and who give as a reason that they are bound by their oaths not to tell," Beattie wrote. "Our people seek no justification outside of their own consciences, and are as ready willing and prepared now as in the past to defend their lives and firesides whenever the necessity arises, and this whether inside or outside of the mere forms of law."[128]

The New Orleans Knights of Labor locals condemned the killings and called for a congressional investigation of the entire affair, but no investigation was ever launched. In the *Journal of United Labor*, a Knights of Labor statement from New Orleans suggested that the killing—and the resulting crushing of the sugar strike's last vestige—was further proof that without strong organization, workers can expect continued wage-bondage. A debate in organized labor circles nationwide appeared critical of Powderly and the Knights' hierarchy for not being more vocal about the atrocity in Thibodaux. The KOL, however, was already in decline, and in short time its influence was to be totally lost to the American Federation of Labor and other union organizing efforts.

Mention of the outrage in Thibodaux—and other violence perpetrated against black people—did make it into the U.S. Congressional Record. The Reverend Ernest Lyon and other clergymen presided over what was billed as a "mass meeting" at Geddes Hall in New Orleans, held on August 22,

1888. A declaration was drafted and approved by those in attendance, its text somehow entered into the record, although no action or further inquiry is known to have resulted.

"That a reign of terror exists in many parts of the state; that the laws are suspended and the officers of the government, from the governor down, afford no protection to the lives and property of the people against armed bodies of whites, who shed innocent blood and commit deeds of savagery unsurpassed in the dark ages of mankind," the statement reads.

> *For the past twelve years we have been most effectively disfranchised and robbed of our political rights. While denied the privilege in many places of voting for the party and candidates of our choice, acts of violence have been committed to compel us to vote against the dictates of our conscience for the Democratic party, and the Republican ballots cast by us have been counted for the Democratic candidates. The press, the pulpit, the commercial organizations, and executive authority of the State have given both open and silent approval of all these crimes. In addition to these methods, there seems to be a deep laid scheme to reduce the Negroes of the State to a condition of abject serfdom and peonage.*

This monument was erected to memorialize men who attempted to overthrow the Reconstruction government in New Orleans in 1874. Originally dedicated to the concept of white supremacy, the monument is among symbols of pro-Confederate sentiments declared nuisances by the New Orleans City Council in 2016. *James Loiselle.*

These acts are done in deliberate defiance of the Constitution and laws of the United States, which are so thoroughly nullified that the Negroes who bore arms in defense of the Union have no protection or shelter from them within the borders of Louisiana. During the past twelve months our people have suffered from the lawless regulators as never before since the carnival of bloodshed conducted by the Democratic party in 1868.

Fully aware of their utter helplessness, unarmed and unable to offer resistance to an overpowering force which varies from a "band of whites" to a "sheriff's posse" or the "militia," but which in reality is simply the Democratic party assembled with military precision and armed with rifles of the latest improved patents, toilers forbidden to follow occupations of their choice, compelled to desist from the discussing of labor questions, and being whipped and butchered when in a defenseless condition…as at Pattersonville and Thibodeaux, they have been traduced in a spirit of savage malignity, the governor of the State, with scarce an observance of the forms of the law has hastened his mercenaries or militia to the scene with cannon and rifles ostensibly to preserve the peace, but actually to re-enforce the already too well fortified Negro-murderers falsely assuming to be lawful posses.[129]

Echoing "Kansas or bust" sentiments, the statement advised blacks to leave Louisiana—indeed, if necessary, leave the United States. Fifteen years later, after ascending within the ranks of African American literati and social reformers, Reverend Lyons was recommended by Booker T. Washington to President Theodore Roosevelt as a candidate for ambassador to Liberia. He held the post from 1903 through 1910, relocating to Baltimore, where he lived until his death in 1938.

A historical mystery that has persisted since the time of the massacre is why, with tensions so high, the state militia was allowed to leave. While General Pierce and his men were not friends to the strikers and other blacks in Thibodaux, there can be little doubt that the mass shootings would not have occurred had they remained.

How heavily this may have weighed on General Pierce cannot be known and will likely never be known.

On July 3, 1889, Pierce entered the armory of his beloved Continentals, eased himself into a comfortable chair in the lounge and ordered a drink from a servant. He then placed his pistol against his head and fired a single shot, dying instantly. Pierce's funeral was a solemn event, and he was laid to rest in the tumulus where also lie other officers of the Army of the Tennessee at Metairie Cemetery, just outside New Orleans, above

The Army of the Tennessee tumulus at Metairie Cemetery, outside New Orleans, is the last resting place for General William Pierce, as well as for his older friend General P.G.T. Beauregard and other Confederate officers. *James Loiselle.*

which a statue of a mounted General Johnston keeps watch, as does a mournful statue of an infantryman near its entrance.[130]

Junius Bailey, the schoolteacher who became an organizer, moved to New Orleans, where he became a coin-striker at the U.S. Mint, which still stands on Decatur Street, now a museum dedicated to Louisiana and New Orleans history. He returned to teaching, eventually heading up the black school system in Plaquemines Parish. Over their lifetime together, he and his wife had twenty children.[131]

At the close of 1887, a year then cited as so crucial for the Louisiana sugar planters, economic losses attributed to the strike were complained of. But recovery was quick.

"The sugar cane crop produced an abundant harvest and because of the price it was very profitable," Père Menard wrote in the conclusion of his first draft of Thibodaux history for that year. "Not in living memory was there a crop that produced so much sugar. This year was a very dry one, almost no rain, a condition which ordinarily presages an abundant crop, especially sugar cane. Christmas was rather depressing because of the bad weather and the bad condition of the roads, which were practically impassable."[132]

THE THIBODAUX MASSACRE

After the Thibodaux Massacre, Jack Conrad left the house he rented on St. Michael Street and returned to the plantation that had been home for most of his life. According to documents in the National Archives, his wife, Mary, had also suffered an injury related to the shooting, though details are not supplied. She died on the Caillouet Plantation in 1888 and was buried either on the grounds or at a small cemetery nearby. During that same year, a massive hurricane, dubbed Number Three of 1888, made landfall at Cocodrie, Louisiana, and barreled inland, its wrathful wind and rain inflicting massive damage to sugar plantations through the parishes of Terrebonne and Lafourche.

In 1890, Jack Conrad's host—the son of the man to whom he had once belonged as a slave—asked if he remembered the names of the men who shot him. Jack said that he did, indeed, remember some of the names. The owner of the land, believed to be Jacques Caillout Jr. or Jacques Caillouet II, gave a benevolent warning that he should leave the area.

"He told me I had to leave, that it was not safe for me to stay," Jack said, explaining how he came to move to New Orleans. He made the disclosures, along with statements describing his injuries and the deaths of his son and his brother, as part of a veteran's pension application in 1893 and investigated by federal examiners.[133] The file includes affidavits of witnesses and transcripts of interviews with them. Uncovered in 2016 during research for this book, the pension file provides the first independent account in official records of what happened in Thibodaux and was located only because a list of eight massacre victims, including Jack Conrad's son, was found the year before in the archives of Nicholls State University.

After moving to New Orleans, Jack married another former slave named Mary, and they lived on Annette Street until his death in 1897 from lung complications. Friends who knew him from his days in the United States Colored Troops during the Civil War and kept in contact with him through the years were of the opinion that his lung condition was complicated by the gunshot wounds suffered at Thibodaux.

EPILOGUE

O ver the decades that followed, the rights of people of color in Louisiana, as in the rest of the South, were eliminated one by one under the laws of Jim Crow, as the "cult of the lost cause" lived on. On the night General P.G.T. Beauregard died in 1893, a committee—which included former Lafourche Parish elections commissioner E.A. O'Sullivan—began an attempt to build a statue honoring the late general. The equestrian statue of Beauregard was sculpted by Alexander Doyle, creator of the Robert E. Lee monument, and in 1915, it was dedicated at the entrance of City Park. Those statues, along with a marker commemorating the Liberty Place riot in New Orleans, were the subject of great public controversy when the majority-black city council voted for their removal in 2015. Telephoned and written threats, presumably made by a fringe of the "lost cause" devotees, resulted in massive delays. A Lamborghini automobile belonging to a contractor who signed up to do the work was set afire.

During the Jim Crow years, through two world wars and the periods of U.S. military involvement in Korea and Vietnam, little changed for laborers of Louisiana's sugar plantations.

Black workers continued living, in some cases, within the same cabins that once housed their enslaved ancestors.

Labor movements were attempted in the 1950s and again in the 1970s, with little effect on conditions of living for those who toiled. There were congressional hearings during the administration of President Richard Nixon. But whatever attention was paid came late. By the early 1980s,

mechanization had heralded the end of the plantation system. Blacks no longer lived or worked on the plantations. Many of the big operations had been broken up into small farms or swallowed whole by real estate developers, some of whom were less than charitable when it came to preserving the burial places of paid sugar laborers and slaves, in some cases wantonly bulldozing over them and pouring concrete for their tract houses and strip malls. Economic disparity in the state still prevails between the races, with black people in Lafourche and Terrebonne still at the bottom end of a wide income gap. The change in status for black people whose families had grown up on the plantations was not all pleasant. Alvin Tillman, the former Terrebonne Parish councilman, recalled how, when he and his family moved off Hollywood Plantation, they were held in low esteem by other black people in Terrebonne Parish.

"For the first time, I heard people who looked like me calling me the 'n-word,'" Tillman said in a 2016 interview for this book. "They called me a 'plantation nigger.'"

Tillman said he hopes he is living up to the dreams of his ancestors. His status as a successful businessman and the first black Terrebonne Parish Council chairman, he said, is in all ways due to their sacrifices. The memory of strikes in which Tillman's forebears took part at the Minor plantations has largely disintegrated. In Lafourche Parish, the fateful events of Thibodaux became further buried. The terror instilled from the time of the strike, as well as the decades and centuries before, is still evidenced through the loud sound of silence. There are other signs of positive change, however. The Very Reverend Shelton Fabre, spiritual leader of the Diocese of Houma-Thibodaux, is black. Terrebonne Parish, although engaged in a lawsuit brought against it by the NAACP, is seeking to make a compromise on a plan that will allow one of its trial court judges to be elected from a special district, to provide a greater chance for its black people to have their judicial candidate preferences better represented.

On a quiet street in Thibodaux in 2015, a journalist seeking black familial memories of the massacre stopped at a house on California Street north of Thibodaux and chatted with a group of people under their carport. As he had done many times before, the visitor asked if the family had heard, maybe from grandparents, of a time when something very bad happened in Thibodaux, something so bad that many black people left. As the people one by one said that no, they hadn't heard of such a thing, an elderly woman seated on the house's side steps raised her head.

"White people came riding through back-of-town; they were on horses, shooting. They shot into the houses," she said. Gently, the visitor asked for

Alvin Tillman, the first black council president in Terrebonne Parish history, talks with historian Margie Bailey Scoby about the African American museum they are developing in Houma. Tillman grew up on Hollywood Plantation, which was owned by the Minor family, as did his ancestors. *John DeSantis.*

more detail, and wanted to know how she had heard of this. The woman shook her head.

"I ain't saying nothing else," she said. "I don't want to get in trouble."

Significant in the woman's initial disclosure was that she had apparently never shared it with members of her family's younger generations, who were right there when she spoke and said they had no such knowledge.

On the part of some people, however, there is a thirst for knowledge of what occurred. A twelve-year-old white student at a Thibodaux charter school, the Bayou Community Academy, was among those. Robert Loupe combed the Internet and the local library in 2015 for all the information he could gather. From his research, Robert learned enough to write a paper on the massacre, and with the help of his mother, Melissa, he constructed a large cardboard exhibit telling the story. The history contest entry did not win. That honor went to a report on antebellum plantations and the people who lived in them. One of the parents had suggested the topic was not suitable for a student of Robert's age.

Middle school student Robert Loupe combed the Internet and the local library for all the information he could gather on the Thibodaux Massacre in 2015, submitting a paper and this exhibit for a history project contest with the help of his mother, Melissa. *John DeSantis.*

Robert accepted the disapprobation. But he is proud of his project.

"People need to know the history of what happened in the place they grew up," he said, explaining his curiosity. "There is always a bad story to it."

"The information as obtained is by hearing my mom talking to someone about the Thibodaux Massacre," the abstract of his paper accompanying the exhibit states. "Those of us there were so confused having never heard about this before. I then became interested in the topic and started to research it more. …This topic, to me, was interesting because our small town of Thibodaux had such a big secret.

"This story," his paper concludes, "is the page torn out of the history book of Thibodaux, Louisiana."

NOTES

Prologue

1. Jack Conrad file, #908205, filed January 31, 1890, Eighty-Fourth U.S. Colored Infantry, U.S. Bureau of Pensions, Washington, D.C.; combined with #862005, widow's pension for Mary Conrad, National Archives, Washington, D.C.
2. Menard, *Annual Journals*.

Chapter 1

3. Merrill and Tolzmann, *Germans of Louisiana*, 40–42.
4. Hall, *Africans in Colonial Louisiana*, 12, 57, 64.
5. Theriot, *Lafourche Parish*, 8.
6. Ibid.
7. Handbook of Texas Online, Texas State Historical Association, https://tshaonline.org/handbook/online/articles/fb045.
8. Walter Prichard, "The Effects of the Civil War on the Louisiana Sugar Industry," *Journal of Southern History* 5, no. 3 (1939): 315–32.
9. Peña, *Scarred by War*.
10. *Louisiana Gazette* and *New Orleans Daily Advertiser*, various 1811 articles cited on the Slave Rebellion website: http://slaverebellion.org/index.php?page=compelete-records-of-charles-deslondes-revolt-2.
11. Ibid.

12. "Slave Narratives: A Folk History of Slavery in the United States," typewritten records prepared by the Federal Writers' Project, vol. 16, pt. 3 (Washington, D.C.: Library of Congress Works Progress Administration, 1941), 125.

13. John DeSantis, "Treasure Beneath Our Feet: Southdown Cemetery's Legacy Lingers," *Courier*, July 1, 2001.

14. Federal Writer's Project Collection, Folder 192, Watson Memorial Library, Cammie G. Henry Research Center, Northwestern State University of Louisiana, Shreveport, LA, 1940.

15. Sprague, *History of the 13th Infantry Regiment*.

16. Prichard, "Effects of the Civil War."

17. Rhodes family, *Gustave Rhodes Jr. Interview*, privately held memorial video, New Orleans, 1984.

18. Caillouet slave record, Lafourche Courthouse.

19. Jack Conrad file.

Chapter 2

20. Menard, *Annual Journals*.

21. Bergeron, *Civil War Reminiscences*.

22. Taylor Beattie obituary, *Louisiana State Bar Association Annual Report* (Baton Rouge, LA: Montgomery-Andree Printing Company, 1921).

23. Andrew Booth, Comm. La. Military Records, in *Records of Louisiana Confederate Soldiers and Louisiana Confederate Commands*, vol. 3, bk. 2 (Ann Arbor: University of Michigan Xerox Services, 1974), 144.

24. Josephine Pugh letters cited in the *Times*, "Small Battle Has Big Local Consequences," November 5, 2014.

25. Fraser, *Fire in the Cane Field*. See also Peña, *Scarred by War*.

26. Sprague, *History of the 13th Infantry Regiment*.

27. Menard, *Annual Journals*, 1863.

28. Steve Michot, e-mail exchange interview, March 2016.

29. Hall, *Story of the 26th Louisiana Infantry*.

30. Jack Conrad file.

31. Curtis, *Black Heritage Sites*.

CHAPTER 3

32. *Harper's Weekly*, "The New Orleans Riot," August 25, 1866, 537.

33. Ibid., "The New Orleans Massacre," March 30, 1867, 202.

34. Records of the Assistant Commissioner for the State of Louisiana Bureau of Refugees, Freedmen, and Abandoned Lands, Washington D.C., in *Register for Applications of Freedmen for Land, 1865–1869*, National Archives Microfilm Publication M1027, Roll 34, "Register of Applications of Freedmen for Land."

35. Ibid.

36. Keith, *Colfax Massacre.*

37. Hogue, *Uncivil War.*

38. Hair, *Bourbonism and Agrarian Protest.*

39. *Louisiana State Bar Association Annual Report.*

40. Senate of the United States, Congressional Series of United States Public Documents, vol. 1549, Third Session of the 42nd Congress, 1872–1873, 751–83.

41. Cowan and McGuire, *Louisiana Governors.*

42. Smalley, *Sugarmaking in Louisiana.*

43. *Daily Picayune*, "The Terrebonne War," January 16, 1874.

44. Johnson and Foner, *Slavery's Ghost.*

45. Ibid.

46. Hogue, *Uncivil War.*

47. *Times Democrat*, "Benjamin's Militia," October 3, 1887. Reprint of 1876 article in the *Thibodaux Sentinel.*

48. Mary Kitchen interview by author, February 2016, Chackbay, LA; follow up of 2009 Reed interview.

49. Rhodes family memorial video.

50. U.S. Congress, *Miscellaneous Documents of the House of Representatives, for the First Session of the 45th Congress, Case of Acklen vs. Darrell* (Washington, D.C.: Government Printing Office, 1877).

51. Ridpath, *Life and Work of James A. Garfield.*

52. State of Louisiana, *Annual Report of the Adjutant General of the State of Louisiana, 1874* (New Orleans, LA: Republican Office, Camp Street, 1877).

53. General Phillip Sheridan, 1875 Letter to President U.S. Grant, cited in *Journal of Negro History* 4 (1919), Project Guttenberg e-book #21093, 2007.

Chapter 4

54. *Daily Democrat,* "A Tragedy: Lynch Law in St. Charles Parish," September 16, 1878.

55. *Times Picayune,* "A Rural Riot," March 19, 1880.

56. Hair, *Bourbonism and Agrarian Protest.*

57. *A History of the Proceedings in the City of New Orleans: On the Occasion of the Funeral Ceremonies in Honor of James Abram Garfield, Late President of the United States, which Took Place on Monday, September 26ᵗʰ, 1881* (New Orleans, LA: A.W. Hyatt, 1881).

58. Voss, *Making of American Exceptionalism.*

59. Foner and Lewis, *Black Worker,* 35.

60. Zinn, *People's History of the United States.*

61. Brexel, *Knights of Labor and the Haymarket Riot.*

62. *Louisiana Planter and Sugar Manufacturer* 21, no. 11 (September 10, 1898).

63. Hall, *Labor Struggles.*

64. Scott, *Degrees of Freedom.*

65. Perkins, *Who's Who in Colored Louisiana.*

66. Conveyance record, Lafourche Parish Clerk of Court, Thibodaux, LA.

67. "Marcus Christian," in *KnowLA Encyclopedia of Louisiana,* edited by David Johnson (n.p.: Louisiana Endowment for the Humanities, 2010). Article published September 15, 2011, http://knowla.org/entry/828/&view=article.

68. *Louisiana Planter and Sugar Manufacturer* 1, no. 6 (1888): 66.

69. Ibid.

70. Jack Conrad file.

Chapter 5

71. John Jackson Shaffer diary, private collection, Shaffer family, Houma, LA.

72. Scott, *Degrees of Freedom.* Also see Hall, *Labor Struggles.*

73. Lafourche Parish Courthouse Records, Criminal Cases Book A, Box 53, Ellender Memorial Library, Archives and Special Collections, Nicholls State University, Thibodaux, LA, 1887.

74. Ibid.

75. *Journal of United Labor*, University of Illinois at Urbana–Champaign, History, Philosophy & Newspaper Library, April 30, 1887.

76. Reinhard et al., *Louisiana Voyages*.

77. J.H. Pharr, *Diaries, 1848–1926* (Morgan City, LA: Archives, 1887), 18.

78. *Daily Picayune*, "The Knights and the Laborers," October 29, 1887.

79. Ibid., October 30, 1887.

80. Ibid., 8.

81. Governor Samuel McEnery to Adjutant General P.G.T. Beauregard, *Original Orders and Correspondence*, Louisiana National Guard Museum at Jackson Barracks Archives, New Orleans, October 1887.

Chapter 6

82. McEnery to Faries, Original Orders and Correspondence, Louisiana National Guard Museum at Jackson Barracks Archives, New Orleans, October 1887.

83. *Times-Picayune*, "Sugar Labor: The Planters United and Determined Not to Yield," October 31, 1887.

84. Ibid.

85. Lafourche Parish Courthouse Records, Criminal Cases, Book A, Ellender Memorial Library, Archives and Special Collections, Nicholls State University, Thibodaux, LA.

86. Ibid.

87. General Orders and Correspondence, Louisiana National Guard Museum at Jackson Barracks Archives, New Orleans, November 1887.

88. Untitled *Times-Democrat* clip, November 3, 1887, National Guard Museum Archives.

89. General William Pierce, *Report to the Adjutant General* (New Orleans: National Guard Museum Archives), 1887.

90. Ibid.

Chapter 7

91. Pierce, *Report to the Adjutant General*.

92. *Times Democrat*, "Particulars of the Affair at Pattersonville," November 7, 1887.

93. Mrs. Mary W. Pugh Papers; A:6, Box 1, correspondence of November–December 1887, Louisiana and Lower Mississippi Valley Collections, LSU Libraries, Baton Rouge, LA.
94. Ibid.
95. *Weekly Pelican*, November 19, 1887.
96. Pierce, *Report to the Adjutant General.*

Chapter 8

97. *Times-Picayune*, "Notice from Knights of Labor Sanctuary District Assembly," November 13, 1887, 4. See also *Weekly Pelican*, November 19, 1887.
98. *Times-Picayune*, "A Bad State of Affairs in Lafourche," November 21, 1887.
99. Pugh Papers.
100. Ibid.
101. *Times-Picayune*, "Proceedings of the Mass Meeting in Thibodaux," November 21, 1887.
102. Pugh Papers.
103. Jeffrey Gould, "The Strike of 1887: Louisiana Sugar War," *Southern Exposure* 12 (November–December 1984).
104. Pugh Papers.
105. *Times-Democrat*, "Thibodaux Riot," November 23, 1887.
106. Lafourche Parish, LA, U.S. Census, 6th Ward, p. 55.
107. *Times-Democrat*, "Thibodaux Riot." See also Lafourche Parish Courthouse Records, Criminal Cases, Book A.
108. Nanny Gay, Gay-Butler-Plater Family Papers, three November 1887 letters, Box 1, Folder 17, Louisiana and Lower Mississippi Valley Collections, Louisiana State University Libraries, Baton Rouge, LA.
109. Pugh Papers.

Chapter 9

110. Jack Conrad file, affidavit of Reverend T. Jefferson Rhodes.
111. Ibid., affidavit of Clarissa Conrad-Jackson.
112. Ibid., affidavit of Jack Conrad.
113. Ibid., affidavit of Clarissa Conrad-Jackson.

114. Pugh Papers.

115. Hall, *Labor Struggles*.

116. *Weekly Pelican*, "Murder Most Foul," November 25, 1887.

117. Ulysses Reed, 2001 interview with John DeSantis, previously unpublished; Mary Kitchen re-interview, 2016, privately held audio recording.

118. *Times-Picayune*, "One of the Wounded," November 25, 1887.

119. Editorial, *Lafourche Star*, "*L'Etoile de Lafourche*," December 17, 1887, cited in Gould, "Strike of 1887"; Scott, *Degrees of Freedom*.

120. Dr. John Gazzo, Inquest on the Body of Willis Wilson et al., Lafourche Parish Courthouse Records, Criminal Cases Book A, Box 145, Item 21, Nicholls State University, Ellender Memorial Library, Archives and Special Collections, Thibodaux, LA, 1887. Also cited as Coroner's Inquest Book A, pp. 209–211 (missing from courthouse).

121. American Legion Raymond Stafford Post 513 Official History, http://centennial.legion.org/louisiana/post513/2013/11/01/raymond-stafford-post-513-history).

Chapter 10

122. *Times-Democrat*, "Thibodaux Riot."

123. Ibid.

124. Pugh Papers.

125. Nanny Gay.

126. *Times-Democrat*, "Bodies of Three More Dead Men Found," November 26, 1887.

127. *Daily Picayune*, "Judge Taylor Beattie," December 3, 1887.

128. Ibid.

129. Foner and Lewis, *Black Worker*, 226–32.

130. *Times-Democrat*, "Death of Gen. Pierce," July 2, 1889, 3.

131. Perkins, *Who's Who in Colored Louisiana*.

132. Menared, *Annual Journal*, 1887.

133. Jack Conrad file.

BIBLIOGRAPHY

Bergeron, Arthur, Jr. *The Civil War Reminiscences of Maj. Silas T. Grisamore*. Baton Rouge: Louisiana State University Press, 1993.

Brexel, Bernadette. *The Knights of Labor and the Haymarket Riot: The Fight for an Eight-Hour Workday*. New York: Rosen Publishing Co., 2004.

Cherry, Rachel E. *Forgotten Houma*. Charleston, SC: Arcadia Publishing, Images of America, 2015.

Cowan, Walter Greaves, and Jack B. McGuire. *Louisiana Governors: Rulers, Rascals, and Reformers*. Oxford: University Press of Mississippi, 2010.

Curtis, Nancy C. *Black Heritage Sites*. Vol. II. New York: New Press, 1996.

Foner, Philip S., and Ronald L. Lewis. *The Black Worker: A Documentary History from Colonial Times to the Present*. Vol. 3. Philadelphia: Temple University Press, 1978.

Fraser, Donald S. *Fire in the Cane Field: The Federal Invasion of Louisiana and Texas, January 1861–January 1863*. Buffalo Gap, TX: State House Press, 2009.

Hair, William Ivy. *Bourbonism and Agrarian Protest: Louisiana Politics, 1877–1890*. Baton Rouge: Louisiana State University Press, 1969.

Hall, Covington. *Labor Struggles in the Deep South and Other Writings*. Chicago: Charles H. Kerr, 1999.

Hall, Gwendlyn Midlo. *Africans in Colonia Louisiana: The Development of Afro-Creole Culture in the Eighteenth Century*. Baton Rouge: Louisiana State University Press, 1995.

Hall, Winchester. *The Story of the 26th Louisiana Infantry, in the Service of the Confederate States*. Gaithersburg, MD: Butternut Press, 1984.

Hogue, James. *Uncivil War: Five New Orleans Street Battles and the Rise and Fall of Radical Reconstruction*. Baton Rouge: Louisiana State University Press, 2006.

Johnson, Walter, and Eric Foner. *Slavery's Ghost: The Problem of Freedom in the Age of Emancipation*. Baltimore, MD: Johns Hopkins University Press, 2011.

Keith, LeAnna. *The Colfax Massacre: The Untold Story of Black Power, White Terror and the Death of Reconstruction*. New York: Oxford University Press, 2008.

Menard, Reverend Charles. *Annual Journals*. Thibodaux, LA: Diocese of Houma-Thibodaux Archival Building, 1888.

Merrill, Ellen C., and D. Tolzman. *Germans of Louisiana*. New Orleans, LA: Pelican Publishing, 2004.

Onebane, Donna McGee. *The House that Sugarcane Built: The Louisiana Burguieres*. Jackson: University Press of Mississippi, n.d.

Peña, Christopher G. *Scarred by War: Civil War in Southeast Louisiana*. Bloomington, IN: AuthorHouse, 2004.

Perkins, Archie Ebeneezer. *Who's Who in Colored Louisiana*. Baton Rouge, LA: Douglas Loan Co., 1930.

Plater, David D. *The Butlers of Iberville Parish, Louisiana: Dunboyne Plantation in the 1800s*. Baton Rouge: Louisiana State University Press, 2015.

Reinhard, Martha, et al. *Louisiana Voyages: The Travel Writings of Catharine Cole*. Oxford: University Press of Mississippi, 2006.

Ridpath, John Clark. *Life and Work of James A. Garfield, Twentieth President of the United States and the Tragic Story of His Death.* Cincinnati, OH: Walden & Stowe, 1881.

Rodrigue, John C. *Reconstruction in the Cane Fields: From Slavery to Free Labor in Louisiana's Sugar Parishes, 1862–1880.* Baton Rouge: Louisiana State University Press, 2001.

Scott, Rebecca J. *Degrees of Freedom: Louisiana and Cuba After Slavery.* Cambridge, MA: Harvard University Press, 2005.

Sprague, Homer B. *History of the 13th Infantry Regiment of Connecticut Volunteers During the Great Rebellion.* Hamden, CT: Quinnipaic University Library Digital Collection, n.d.

Stampp, Kenneth M. *The Peculiar Institution: Slavery in the Antebellum South.* New York: Alfred A. Knopf, 1956.

Theriot, Clifton. *Lafourche Parish.* Charleston, SC: Arcadia Publishing, n.d.

Voss, Kim. *The Making of American Exceptionalism: The Knights of Labor and Class Formation in the Nineteenth Century.* Ithaca, NY: Cornell University Press, 1993.

Wall, Bennett H., et al. *Louisiana: A History.* 2nd ed. Arlington Heights, IL: Forum Press, 1990.

Zinn, Howard. *A People's History of the United States.* New York: Harper Collins, 1980.

INDEX

INDEX

INDEX

ABOUT THE AUTHOR

John DeSantis is the senior staff writer at the *Times of Houma*. A product of New York City, his work has previously appeared in the *New York Times*, the *Washington Post* and other publications. A journalist whose criminal justice background was attained at John Jay College of Criminal Justice in New York, he has covered social justice and race relations extensively in New York, Louisiana, Mississippi, Florida, North Carolina and California. He is also a former city editor at the *Thibodaux Daily Comet*. His other books include *For the Color of His Skin: The Murder of Yusuf Hawkins and the Trial of Bensonhurst* and *The New Untouchables: How America Sanctions Police Violence*. A recipient of numerous awards from the Louisiana Press Association, the Associated Press Managing Editors Association and other news media organizations, he resides in Terrebonne Parish, Louisiana.

Visit us at
www.historypress.net
..

This title is also available as an e-book